HARDEEP PANDHAL
INHERITANCE QUEST

■■■■ black dog press

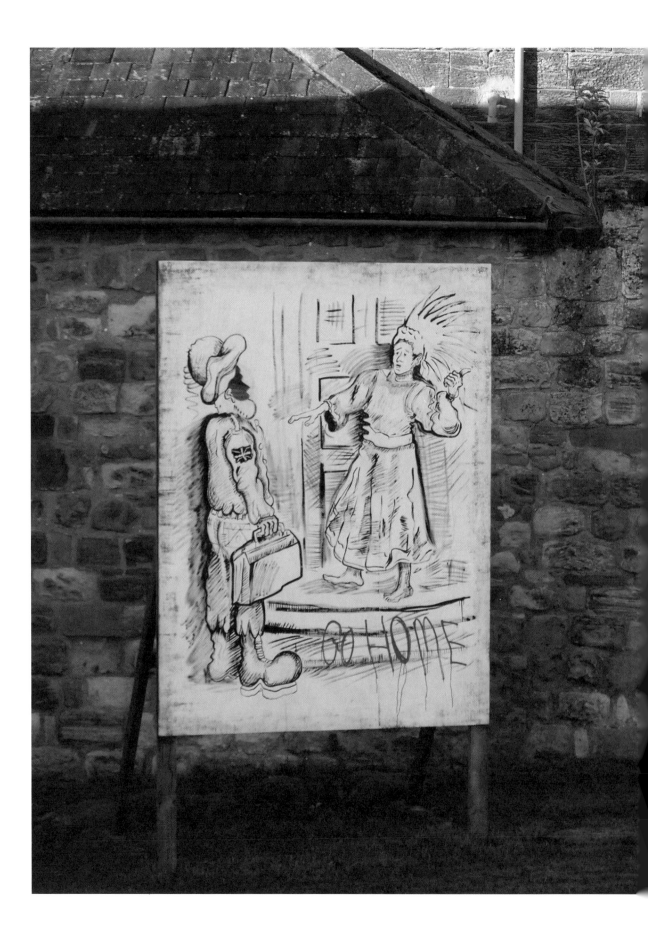

Go Home (Komagata Maru Incident), 2017

CONTENTS

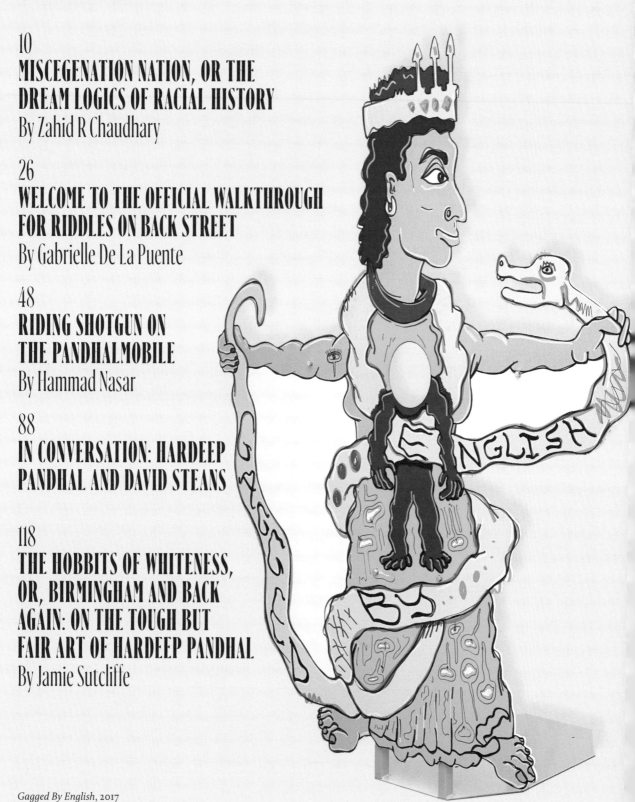

Gagged By English, 2017

BAME Me On History, 2017

Opposite
Happy Punjabi Gothic 6, 2019

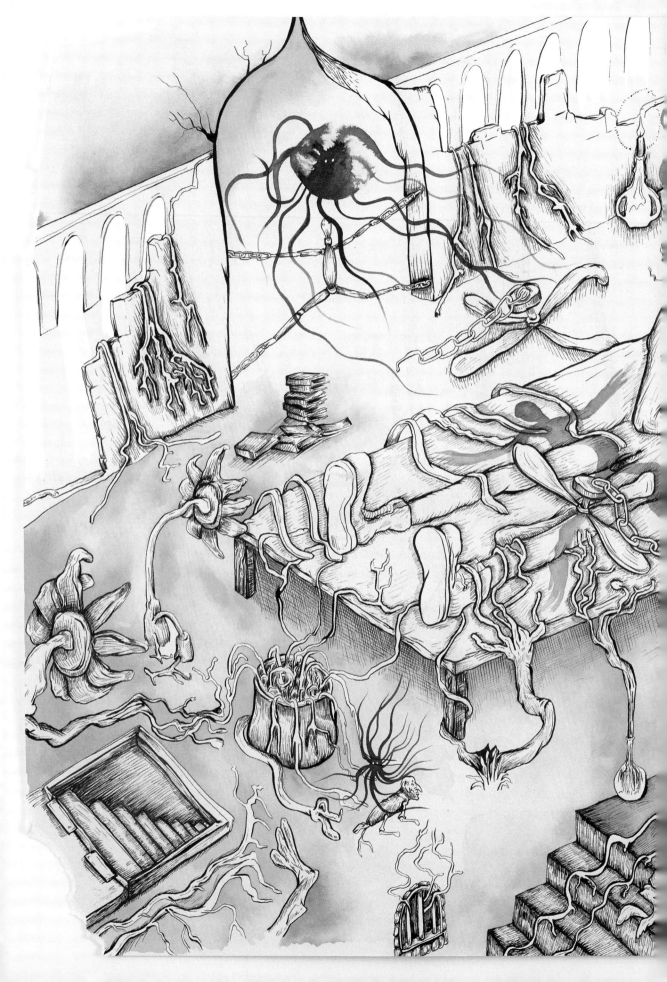

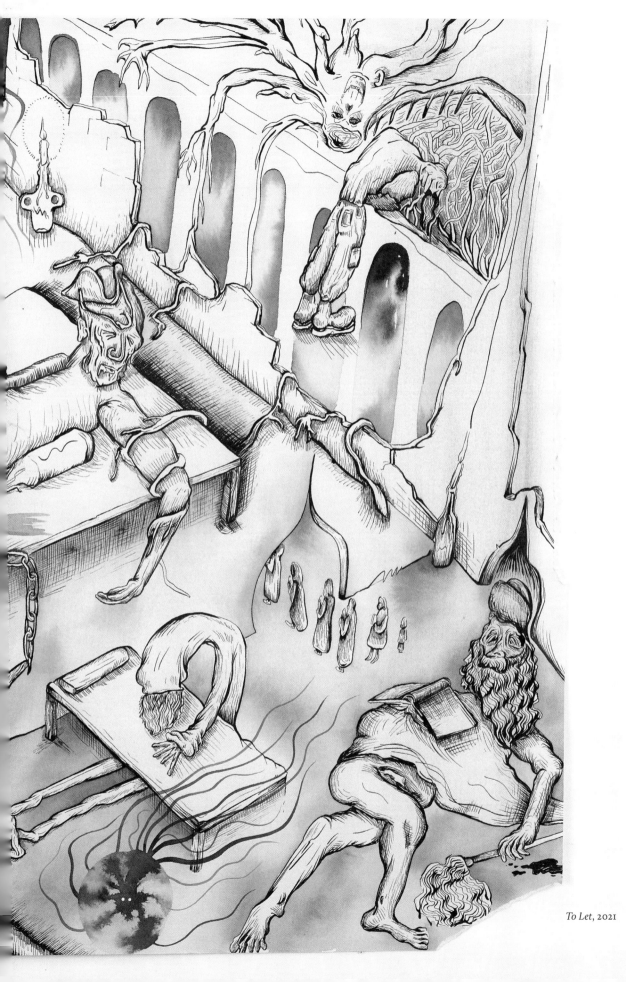

To Let, 2021

MISCEGENATION NATION, OR THE DREAM LOGICS OF RACIAL HISTORY

BY ZAHID R CHAUDHARY

Hardeep Pandhal works across a variety of media with a playful sensibility that engages deadly serious topics such as racial violence, minoritisation and the haunting of cultural traditions. In the light-hearted and simultaneously terrifying worlds depicted in Pandhal's work, empire has ended but the libidinal – even orgiastic – energies upon which it depended have not dissipated. The racism that governed colonial history and generated its own forms of pleasure and lordly gratification finds new expression in the forms of mass culture that Pandhal uses in his work, including cartoons, toys, rap and video games. Objects of personal nostalgia, these are also linchpins for the alternative fantasy worlds that frequently make an appearance in Pandhal's art. Never merely escapist, these worlds – most fully realised in his early work as animation – are freighted by the racial menace encoded in these toys and cartoons. What to do if one is nostalgic for representations that have proved injurious to oneself? Pandhal's work suggests that a headlong dive into the Dionysian and carnivalesque dream logic of racial history is the only appropriate response.

Pandhal investigates this history – personal and collective – through playful techniques of improvisation, performance and repetition. While this playfulness is never unserious, it courts danger and is unafraid of becoming dangerous itself. In some of his animations, for example, the same repeated laughter or exclamation becomes both joyous release and racial threat, as past traumas return in the guise of pleasure. The human figure in Pandhal's artwork transmogrifies according to the demands of racist invective, Sikh tradition and cultural assimilation. Since these demands are contradictory, fabulism, excess and irony become the aesthetic strategies of choice for their investigation. Consider the description of the 1980s television series *The Jewel in the Crown*, as heard in Pandhal's 2020 animation piece *Ensorcelled English*:

> Basically there's an interracial couple – an Indian man and white woman – who get attacked by local Indians whilst making love outdoors. The man gets thrown into prison and is raped himself by a colonial officer. The woman dies in childbirth … Everything happens in the first couple of episodes. Hardly anything happens in the remaining ones, it's weird.

This account suggests that *The Jewel in the Crown*'s excess lay not only in the lush and glittery surfaces on which the camera lingered, but also in the narrative of lurid sexuality: lovemaking leads to mob violence leads to rape leads to death. Crucially, *The Jewel in the Crown* imputes mass hysteria about interracial mixing to the Indian population, even though historically it is the British who have inflicted violence on Indian populations in the service of "protecting" white womanhood from brown men. It is this excessive and nearly gothic organisation of sex and death under colonialism that is repressed by orientalist images of crown-encrusted turbans, peacock feathers and "Saracenic" architecture at twilight. Yet the speaker in Pandhal's animation describes this garish aspect in the deadest of deadpan voices. Her voice lends irony to the description, and such irony has the effect of highlighting the preposterous nature of Raj-nostalgia fantasies but without detracting from the horror of racial terror upon which empire depended – and which is now revealed as the true longing underwriting the nostalgia for empire.

Pandhal's work returns consistently to this form of irony, rescuing the ironic mode from the degraded forms it often takes in contemporary online cultures: the rhetorics of the meme, the culture of "lulz", the winking admission of all things terrible and profane. These debased varieties of irony are the preferred idioms of post-truth culture and the delusional politics to which it leads. Untethered from the social realities that have produced such politics, contemporary degraded forms of irony cede ethics and accountability in the service of pleasure and gratification. Pandhal restores to irony its powers of critique and critical distancing, exposing the opposition between ethics and pleasure as false. In *Happy Thuggish Paki*,

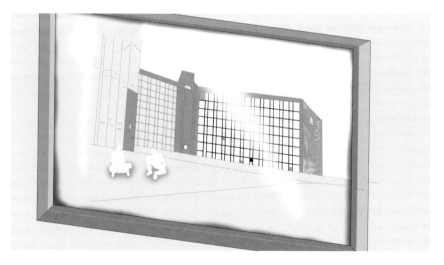

Stills from *Ensorcelled English Rector's Cut*, 2021

Stills from *Ensorcelled English Rector's Cut*, 2021

a figure of childhood nostalgia, Ms Pac-Man, repeatedly addresses her husband as "Paki". The figure of a young Sikh boy, his heart throbbing, sits in front of the television screen watching Ms Pac-Man ask "Paki? Aren't you done shaving yet?", and the rest of the phantasmagoric animation, in which the figure enters an alternative fantasy world, is overlaid with a track of Pandhal rapping about a host of related topics that return to a single theme: the nature of fantasy. The lyrics imagine a world without whiteness:

> Curing eternal damnation with genetic variation / On the BAME of Thrones overlooking my miscegenation nation / Where every single person looks at least half Asian.

This fantasy is undercut, perhaps even punctuated, by Ms Pac-Man yelling out "Paki" again and again, tracking the rhythms of the rap itself. Pandhal's use of irony extends even into the sonic elements of this piece. An innocent word becomes racist invective in the British context, and the repetition of the slur generates the very irony that it simultaneously roots in social reality. There is no easy escape from social reality, and the long fabulist sequence that takes up much of the animation is bookended by starkly documentary scenes of Pandhal describing his artistic process. Within the fantastical and nightmarish part of the animation, social reality intrudes in the form of social demands. For a young Sikh boy in Britain, the demand to shave is a form of assimilative coercion, and the phantasmagoric sequence of this piece starts with this demand. As the video unfolds, the turbaned figure reveals himself to be capable of extreme shape-shifting: in the dreamwork of a racist society, this figure is a Sikh, an Arab, an outsider, both Pandhal and Osama bin Laden. Crypto-satanic symbols – sometimes in the figure of the trickster Punjabi that repeats across several of Pandhal's artworks, including *Happy Punjabi Gothic* (2019) – proliferate in the cultural imaginary of British whiteness. In the dream logic of Pandhal's animation, such majoritarian cultural imaginaries are given to excess and are akin to online platforms, like

"For a young Sikh boy in Britain, the demand to shave is a form of assimilative coercion, and the phantasmagoric sequence of this piece starts with this demand"

the browser-based game *Osamagotchi*, released in the wake of the September 2001 attacks in America, which offers users the "pleasures" of either torturing the beturbaned Osama bin Laden figure or keeping him as a pet. The incantatory rap that accompanies the artwork is confession, prayer and explanation all at once – yet it remains haunted by Ms Pac-Man's cartoonish refrain, "Paki!"

Irony, fabulism and excess are themselves modes of play in Pandhal's work. The hirsute figure of the Punjabi male in the series entitled *Happy Punjabi Gothic* presents the stereotypical attributes of the Punjabi male to support a variety of trickster performances: striking a pose here, upending expectations elsewhere. The chains and severed body parts that frame these images suggest the limits of such penned-in masculine performances, but also the sadomasochistic play that might assist in mastering those limits. The unruliness of unconscious impulses is ever-present in Pandhal's work, giving it the quality of dreamwork in Sigmund Freud's precise sense: symbolisation and representation as condensed manifestations of the psyche's attempts to work through lived social realities. For Pandhal, the turban is an exemplary symbol in this regard, deemed in a racist world to signify Sikhism, "Islamic terrorism", racial threat and so on. While this racist signification of the turban abets racially motivated sadism, it allows little room to consider how the turban's other inflections, such as family tradition or cultural patrimony, might also constrain the human figure – even while offering it possibilities of self-expression. *Happy Punjabi Gothic* takes the risk of doing exactly that. Across this series, as in other works by Pandhal, historical repetition reveals itself as both a traumatic symptom and a reactivation of the past's unrealised potentials.

Stills from *Happy Thuggish Paki*, 2020

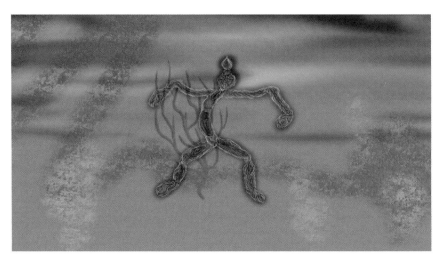

Stills from *Happy Thuggish Paki*, 2020

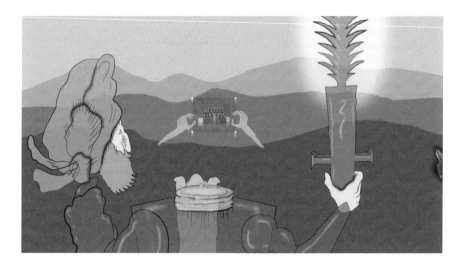

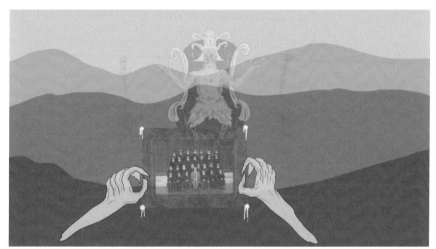

Stills from *Happy Thuggish Paki*, 2020

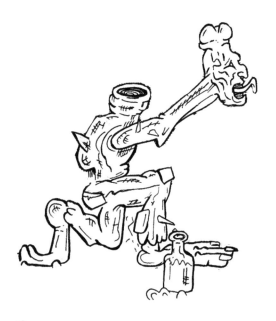

Opposite
Whitby Goth Festival, 2021

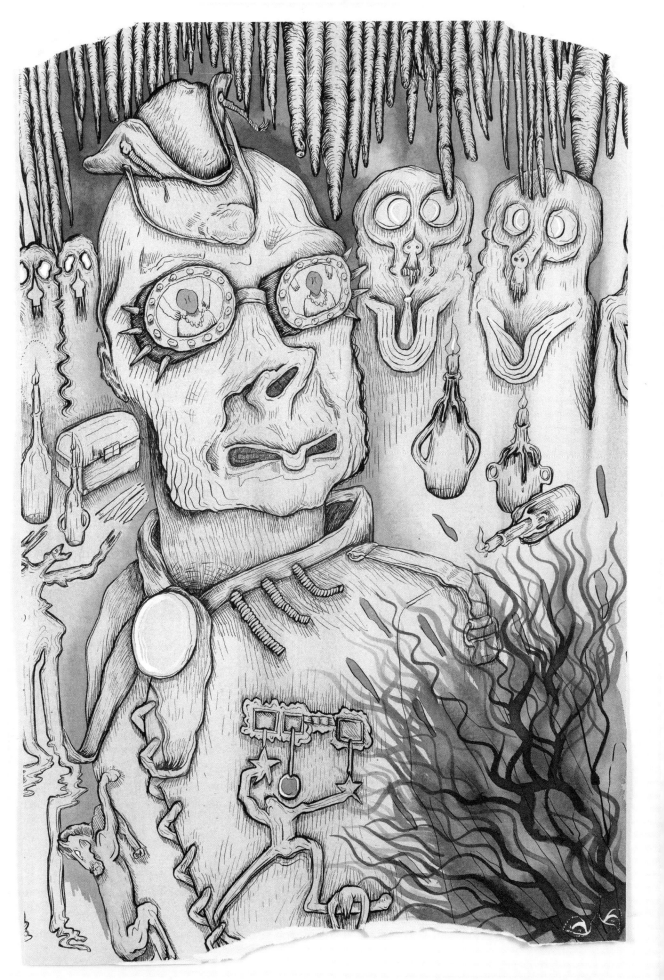

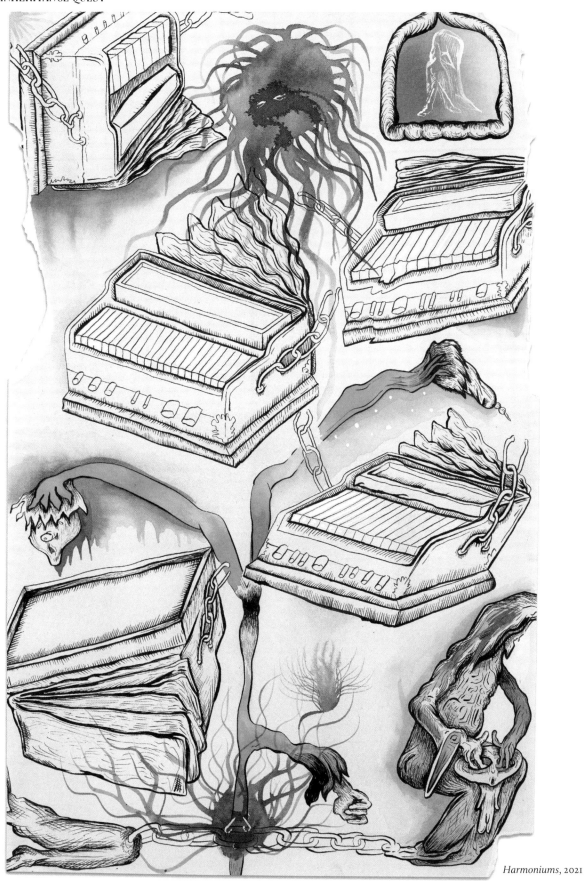

Harmoniums, 2021

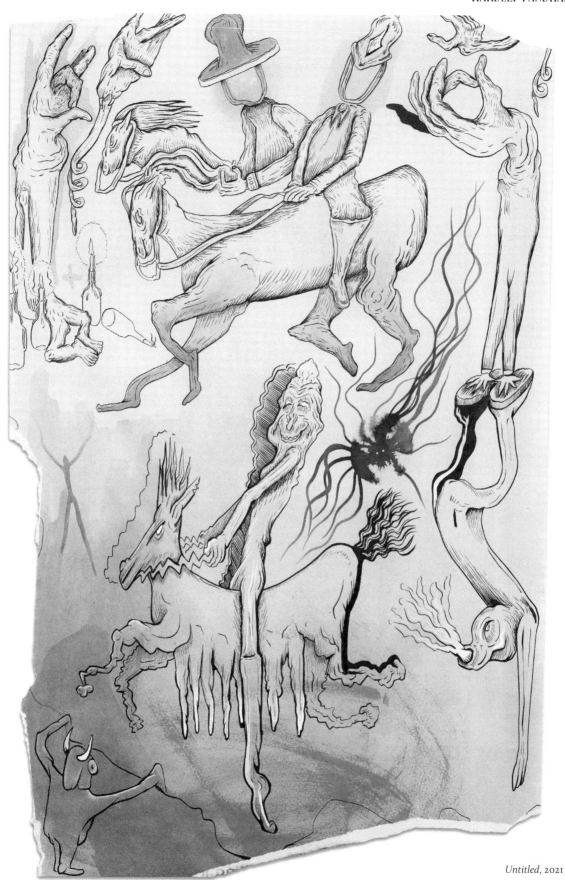

Untitled, 2021

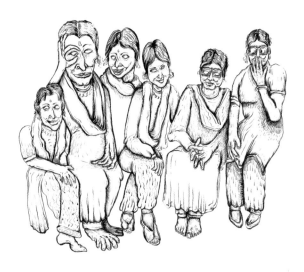

Opposite
Uber Eats Me, 2021

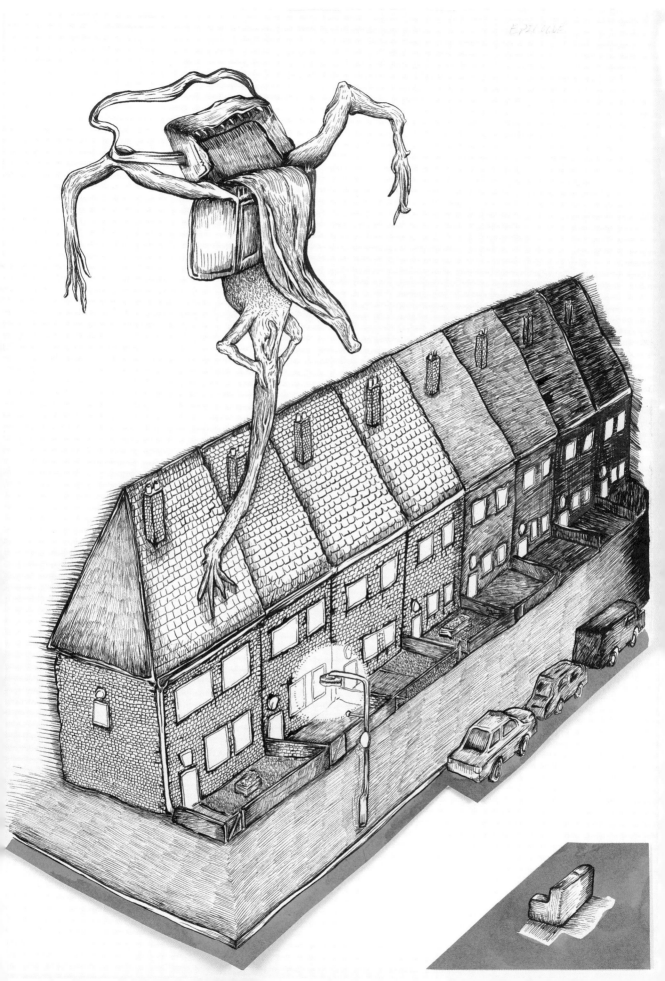

Stills from *Riddles on Back Street*, 2021

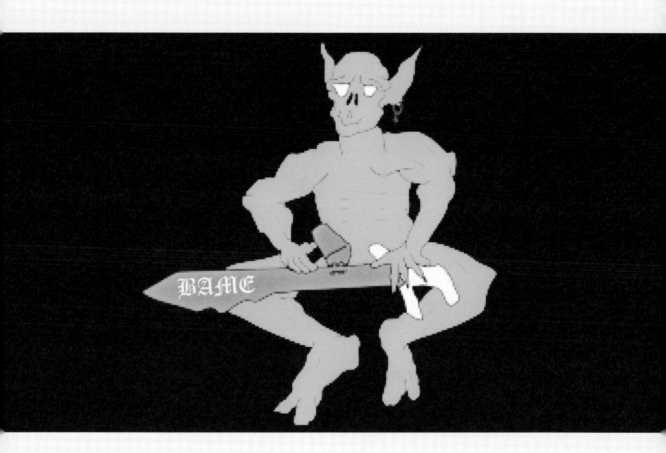

```
        /|  _____
O|===|* >_____   >
        \|
```

WELCOME TO THE OFFICIAL WALKTHROUGH FOR RIDDLES ON BACK STREET

```
        /|  _____
O|===|* >_____   >
        \|
```

BY GABRIELLE DE LA PUENTE

THIS IS A BEGINNER'S GUIDE TO THE 2021 HD YOUTUBE VIDEO
*RIDDLES ON BACK STREET. MIDIEVIL X VANDALORUM FEATURING
MISTER UGLY,* A COLLABORATION BY HARDEEP PANDHAL AND
ADAM SINCLAIR. WHETHER YOU'RE AN EXPERT ART EXPERIENCER
OR YOUR SKILLS ARE RUSTY, THIS WALKTHROUGH IS DESIGNED
TO MAKE SURE VIEWERS GET THE MOST OUT OF THEIR TIME
WATCHING. THE FILM IS PACKED WITH SECRET ITEMS AND SIDE
QUESTS FROM THE TITLE SCREEN TO THE FINAL CREDITS. MAKE
SURE TO READ ON FOR THE LOCATIONS OF ALL COLLECTIBLES,
AS WELL AS TIPS ON THE BEST ART-EXPERIENCE STRATEGIES.

HOW LONG TO BEAT
MAIN STORY: 4 MINUTES 45 SECONDS
COMPLETIONIST: NOT ENOUGH DATA

```
      /$$        /$$       /$$ /$$
     |__/       | $$      | $$| $$
  /$$$$$$  /$$ /$$$$$$$ /$$$$$$$| $$ /$$$$$$  /$$$$$$$
 /$$__  $$| $$| $$__  $$ /$$__  $$| $$ /$$__  $$ /$$_____/
| $$  \__/| $$| $$  | $$| $$  | $$| $$| $$$$$$$$| $$$$$$
| $$      | $$| $$  | $$| $$  | $$| $$| $$_____/ \____  $$
| $$      | $$| $$$$$$$| $$$$$$$| $$| $$$$$$$ /$$$$$$$/
|__/      |__/_____/_____/ |__/_____/|_____/
```

```
         /$$                            / $$
        | $$                           | $$
 / $$$$$$ /$$$$$$$$  | $$$$$$$ /$$$$$$ /$$$$$$$| $$   /$$
 / $$__  $$| $$__  $$ | $$__  $$ |___  $$ /$$_____/| $$  /$$/
| $$  \ $$| $$  \ $$ | $$  \ $$ /$$$$$$$| $$      | $$$$$$/
| $$  | $$| $$  | $$ | $$  | $$ /$$__  $$| $$      | $$_  $$
| $$$$$$/ | $$  | $$ | $$$$$$$/| $$$$$$$| $$$$$$$| $$ \  $$
 _____/ |__/  |__/ |_____/ _____/ _____/|__/  \__/
```

```
      /$$                           /$$
     | $$                          | $$
 /$$$$$$$$ /$$$$$$  /$$$$$$  /$$$$$$ /$$$$$$  /$$$$$$
/$$_____/|_  $$_/ /$$__  $$ /$$__  $$ /$$__  $$|_  $$_/
| $$$$$$   | $$  | $$  \_/| $$$$$$$$| $$$$$$$$| $$
 \____  $$  | $$ | $$ /$$| $$  |  $$____/| $$_____/ | $$  /$$
/$$$$$$$/  | $$$$/| $$   | $$$$$$$| $$$$$$$ | $$$$/
|_____/  |____/ |__/    _____/ _____/  |____/
```

27

PREVIOUSLY ON
Continuing in the vein of previous Hardeep Pandhal titles, *Riddles on Back Street* is a fast-paced animation with a rap soundtrack that presents a surreal discussion on identity, class and power through visual art and lyricism.

TIPS AND TRICKS
> Hardeep Pandhal makes work that collages a lot of styles and sources together. This piece is a loud harmony that pulls from game design, storytelling, music, personal histories and tropes in visual media. The layering is rich. Because there is a lot to unlock, I recommend watching it once without knowing anything and then again after you know everything.

> Remember, this isn't being shown to you in a gallery. It's on YouTube. You can pause it whenever you want, rewind, re-watch, and put it on loop.

> Your task as the art experiencer is to watch what happens on-screen, listen to the music, consider the lyrics, and let the totalising effect of the collage have a totalising effect on you. When it's over, figure out what your own reaction to the work is and, more importantly, what that reaction means.

Are you ready?

Lfgggggggg

LEVEL 1: I'M OLD AS SHIT, WASN'T LIKE THIS IN MY DAY
The title screen presents the words "UBER EATS ME" in a ye olde font style and credits the work to 'MIDIEVIL X VANDALORUM FEATURING MISTER UGLY'. These words fly onto the screen in word-art-style animations, appearing over a trashy galaxy background to the sound of royal pipes as though something important is about to happen... there's already a lot to unpack in the first 15 seconds.

The opening sets up one of the threads that continues throughout the rest of the piece: a bringing together of old and new. Jarg graphics reference casual trap videos on YouTube, signalling all the hi-hat-backed rap to come. Meanwhile, the pipes, font and MIDIevil character allude to the Sword and Sorcery fiction the artist continues to reference across his work, MIDI being a protocol used in lots of electronic musical instruments, and here a play on the word "medieval". The pun also brings to mind dungeon synth music and neo-medievalism trends.

* * *

Fun fact: Pandhal was reading Fritz Leiber's 1939 – 88 Lankhmar series when he made this. The "back street" from the video's title was inspired by Leiber's generic way of naming streets in his fantasy worlds, wherein genericism allows the reader space to project their own imagination over the author's description.

* * *

So, why does the artist come back to the Sword and Sorcery genre time and time again, and what does it do to *Riddles on Back Street*? Because we go on to see it in the form of goblins, a sword stuck in a stone, flutes, loincloths, mention of Grendel (an antagonist from *Beowulf*) and antiquated punishments involving chains, decapitation and the line "I can see through my own head on a spike." It is a gnarly genre but it's finding its way into the work of many artists today who are letting us see into their own worldbuilding designs through windows in their artworks. Drawing on traditional fantasy elements could simply be an invite to an escapist fantasy in the context of permacrisis. God knows we need one.

Pandhal's artistic process is one connection to Sword and Sorcery. He does a lot of ink drawing, and manually dipping brushes into ink pots is an archaic method by any measure. The artist's Sikh heritage is another, because it is a religion that places a lot of symbolism in militarisation – in the saint soldier, Sant Sipahi, for example, and the kirpan, a curved dagger that is one of the five articles of faith that must be worn at all times.

When it comes to *Riddles on Back Street*, the medieval undertones resist ethnic codification and deflect what might be expected of the artist by the audience and the institution. That is because the fantasy imagery of knights, princesses, peasants – and kings on the Solitaire cards in the last quarter of the film – are all associated with whiteness in the cultural imaginary. Gaming is as well, and rap is tied to Black artists. This evasiveness works to free Pandhal from having his work read in a singular way, so that he can go on to discuss identity politics on his own terms. And actually, the film opens with that construct, if you recall the opening sample of "#BAME, BAME, BAME" repeated in that initial olde font as a goblin hammers a sword across its lap.

> *#BLACK, ASIAN AND MINORITY ETHNIC. BLACK, ASIAN AND MINORITY ETHNIC. BLACK, ASIAN AND MINORITY ETHNIC#*

The evasiveness makes the style vague and the conversation vast. What do we actually mean when we collapse identities into these phrases? Why do we restrict genres in the same way? Speaking through old and new styles at once infers a flattening of time, history repeating itself – or there being a timelessness to our problems. Mister Ugly's line, "I'm old as shit, wasn't like this in my day", speaks to the ambiguity of the country *going backwards* depending on where you're looking from – driving straight ahead or looking into the rear-view mirror.

LEVEL 2: A RIDDLE GAME
Riddles on Back Street is filled with game references. Here are the locations so you can catch them all:

0:19 The goblin is styled as a non-playable character (NPC) that you might speak to for information or items. The arm swinging to polish the boot is a nod to pendulum blades that players have to avoid in dungeon games. Plus, the post-production pixel effect aims to bring everything closer to a game art style; Pandhal was reading about video game demakes at the time, i.e. the process of converting games to older graphic styles to create nostalgia.

0:33 "Lived my life on low health so I ain't scared of death" is a comment on the survival aspect common to so many video games, but it is phrased almost as if it is a challenge to the enemy. It infers that limits can be conducive to creativity and to generating a greater sense of reward when overcoming barriers.

0:51 "If you don't know the password to get in you must win in a riddle game let us begin and if you cannot win you must treat it as sin"; the lyrics attach a moral judgement to the success or failure of the player, and suggest that some people already know the way forward, while others do not.

0:57 There's a figurine on the dashboard of an Arthurian figure pulling a sword out of a stone. In the green tunic, it looks like Link, the protagonist from *The Legend of Zelda,* who made his first appearance in 1986.

1:12 The fingernails change colour and cycle through the Union Jack, St George's Cross and the UKIP logo, similar to the player customising their avatar in a character creator.

1:34 A figure based on *Mario Kart*'s Lakitu appears, which is a small turtle-like creature that floats onto the screen riding a cloud to wave the start of a race.

1:38 The character wrapped around the sword is based on *Zelda*'s Link.

2:10 Mister Ugly sings "the only way to win the game is not to play" in a refrain as the car knocks into other drivers on the motorway. It is a similar scene to the 1995 game *Destruction Derby*, except the car doesn't suffer any damage.

2:33 We see another character creation scene as the driver's arms change from green ones wearing a spiked bangle, to those of a dark-fantasy-style character, an octopus and then a man.

2:35 The sky flicks between a sun and a moon in a reference to famous motorcycle racer Valentino Rossi, whose logo - a sun and a moon - is used in a popular Monster Energy Drink partnership. In the driver's seat, Pandhal alludes to gaming as a sport and specifically the rising popularity of e-sports.

2:39 The yellow taxi is taken from the Sega game *Crazy Taxi*, which the artist played a lot as a teen. Unusually, the taxi is being driven by Solid Snake, who is the main character from *Metal Gear Solid*, a techno-thriller series of games created by Hideo Kojima that is known for stealth, cinematics, and for breaking the fourth wall.

2:57 The Uber bag is in a pixelated state before getting punctured from the inside by a sword, transforming into a 2D cell-shaded version of itself. It deflates – dies – and then floats back down into the scene having been re-spawned, implying a mysterious cycle that needs breaking so that it can be properly defeated. This positions the Uber bag as a game enemy, which we'll come back to in Level 3.

3:23 An animation of solitaire appears in the sky from the free version of the one-player card game that comes installed on Microsoft PCs. Also called Patience, the cards have to be arranged into an ordered system to win the game.

3:28 The camera turns to reveal that there is no body attached to the arms holding the wheel. At the time of making, the artist was watching *Boundary Break*, a YouTube series that explores hidden areas of games using unofficial virtual camera mods. Sometimes unused assets are revealed in the process, and it can be strange to know there are all these things hiding in the walls when players go about their business.

3:35 The car's satnav is showing 3D Maze, an animated Windows 95 screensaver that was reminiscent of the first-person-shooter DOOM from 1993.

3:37 Solid Snake is now the passenger in the backseat.

3:45 The UI outside of the car now mimics *Metal Gear Solid*, showing that the inventory is holding cigarettes. In *MGS*, players could use smoke from a cigarette to detect infrared beams connected to bombs. It is a clever piece of game design that Pandhal appreciates to this day.

4:01 The cigarettes in the inventory have been switched out for a "tattered loincloth", which is a starting item for the most difficult class in *Dark Souls*. That 2011 game is renowned for its high level of difficulty and its masocore sub-genre, meaning a game that requires the player to adopt a frustrating trial and error approach in order to figure something out.

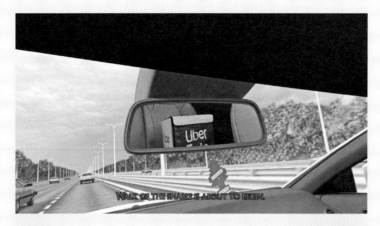

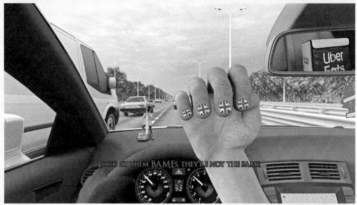

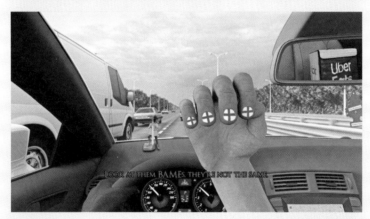

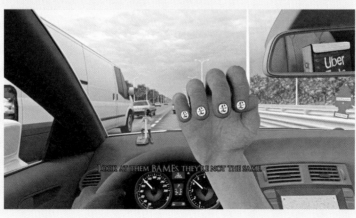

Stills from *Riddles on Back Street*, 2021

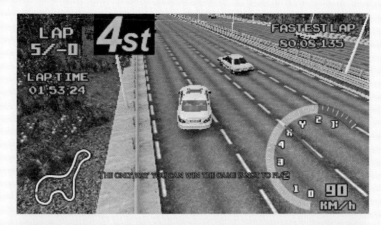

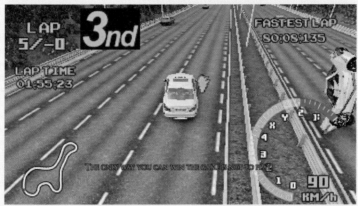

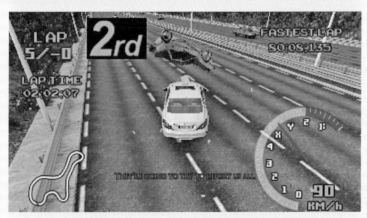

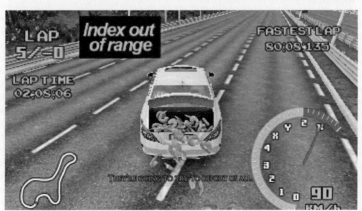

Stills from *Riddles on Back Street*, 2021

WALK OF THE SHAME THE WALK OF THE BAME

THEY ARE THE SAME ONE IS JUST SANE I AM JUST SAYING

THE CURE FOR THE PAIN IS IN THE PAIN

THE CURE FOR THE SHAME IS IN THE BAME

LOOK AT THEM BAMES, THEY'RE NOT THE SAME

OVER THE REST ONE HAS MADE GAINS

IT HAS GOT BREASTS WITH INK IN ITS VEINS

PUMPING OUT BLACK INK ALL OVER THE SEATS IN MY TAXI

THE UBER EATS ME FROM THE BACK SEAT

CUT MYSELF LOOSE FROM THESE BAMES BEFORE I LEAVE MY NECK

Lyrics from *Riddles
on Back Street*, 2021

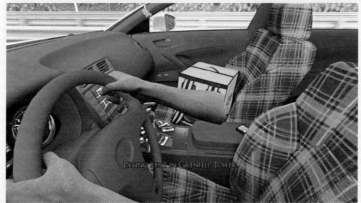

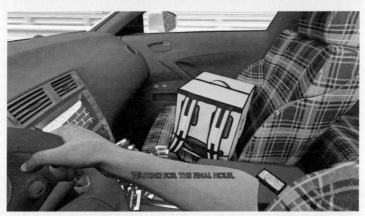

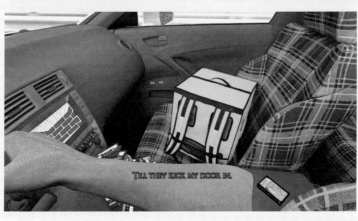

Stills from *Riddles
on Back Street*, 2021

Why so many game references? Artists often speak through their own vocabularies, which are made up of a culture they are familiar with or one in which they place a lot of value. Pandhal grew up playing games and still does, and that influence shows. For *Riddles on Back Street*, the use of game references supports the overall messaging and even the medieval theme. Plenty of modern titles wear the aesthetics of Sword and Sorcery fantasy – *The Legend of Zelda*, for example – and they do so because of the influence of Dungeons & Dragons. D&D fused ideas from Tolkien with the practice of simulating war games; the heroic fantasy suitably fulfils the aims of the gamer who is presented with a challenge to beat, a dragon to slay, a game to win.

Here, the presence of NPCs, Uber-bag bosses and protagonists wielding swords in high-difficulty-level environments turns the subject of the rap into the narration of a game. Except in *Riddles*, "the only way to win the game is not to play". "The game" in rap refers to the unpredictability of success in the music industry – here it might mean the unpredictability of survival in the United Kingdom for those who are #BAME, BAME, BAME#. The only way to win is to not be here. We have a hostile environment for refugees, who risk violent detention centres and deportation; a failing healthcare system for anyone who suffers from "low health"(0:33); and a cost of living crisis alongside a precarious labour environment after Brexit, which takes us nicely to Level 3…

LEVEL 3: UBER EATS ME

> *#PUMPING OUT BLACK INK ALL OVER THE SEATS IN MY TAXI*
> *THE UBER EATS ME FROM THE BACK SEAT#*

Was the Uber bag in the back seat just an Uber bag in the back seat, or did you see it as a proper entity and a character in its own right? Because by reading *Riddles on Back Street* through the lens of our Level 2 game knowledge, we can take the Uber bag to be an immortal (game) boss who can only be defeated through the trial and error masocore approach. And as it's Uber, the bag could well symbolise the problems with the gig economy. It's a comfortable interpretation because so many gig workers are wary of the gamification of their own labour; addictive work with apps beeping endlessly, limited-time modes, reward systems, unlockable badges and many drivers figuring out their own best strategies to win.

> *#I GOT ATTACHED TO MY UBER BAG*
> *DON'T TAKE ME AWAY FROM MY UBER BAG#*

In the video, even when we see the goblin character stab the Uber bag from the inside and then fly away on the sword, the bag re-spawns instantly. So what now? This happens in a fast scene towards the end. So it's time to move on to the final section.

ENDING EXPLAINED

The failed attempt at killing the Uber bag suggests that these institutions cannot be dismantled from the inside. What options does the player have left? We watch the driver of the taxi swerving *Destruction Derby*-style into everybody else on the motorway, with car parts and debris flying all over the screen. But in spite of all the crashes, the health bar at the top left of the screen stays fully green. It's as though the Uber driver has been driven mad trying to defeat the boss, so they hurtle their own car into others on a suicide mission to free themselves from Uber's grip – to no avail. It is an overwhelming problem, and Mister Ugly's line "the only way to win the game is not to play" comes back into the fold. It is nihilistic. Uber is a hydra with more lives than us. The only way to win is to not try; to not martyr yourself trying to make things better.

The "uber eats me" statement is final and continuous.

The last thing we see is the dripping, decapitated head of Sean Bean. The actor is famous for his characters dying on screen. He dies early on in *The Lord of the Rings* and in *Game of Thrones*, but he has died in 21 titles to date. Bean also dies in video games, most notably as the antagonist of the 1997 *GoldenEye 007* on the N64. Death has become so associated with Bean's image that in 2019, the actor pronounced he would not take on any more roles that resulted in his character's end. Two years later, Pandhal would make *Riddles on Back Street*. Is he lamenting death's inevitability? Is he mocking the actor's typecasting? Is he saying that nobody can outrun the curse of the neoliberal uberisation of the labour market, not even the previously working-class actor Sean Bean? I don't know. The video ends.

GAME OVER

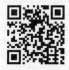

Scan QR code to view *Riddles on Back Street*

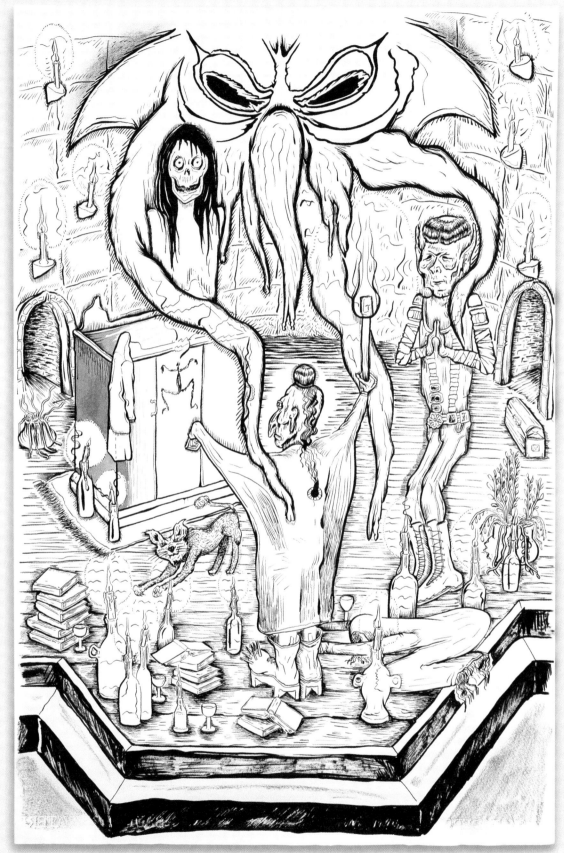

Thugs and Vandals, Charmed By Gorgoroth III, 2021

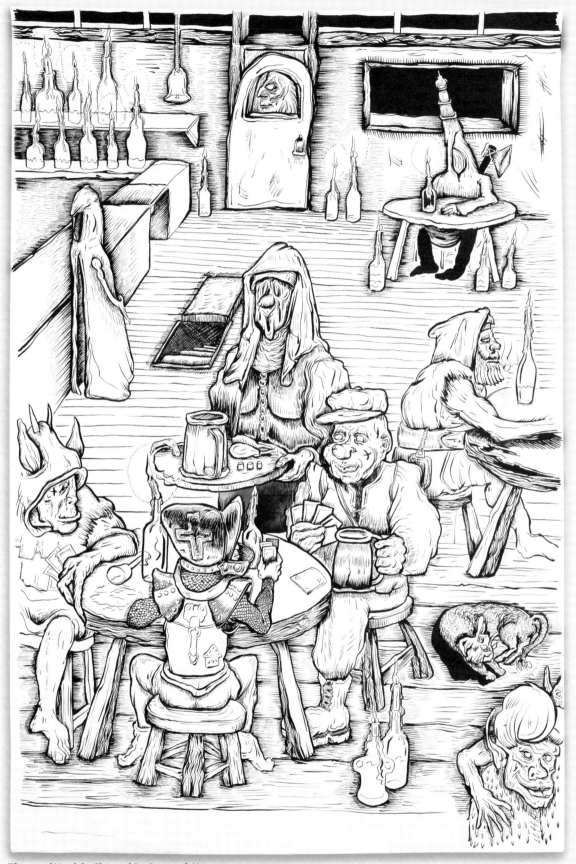

Thugs and Vandals, Charmed By Gorgoroth V, 2021

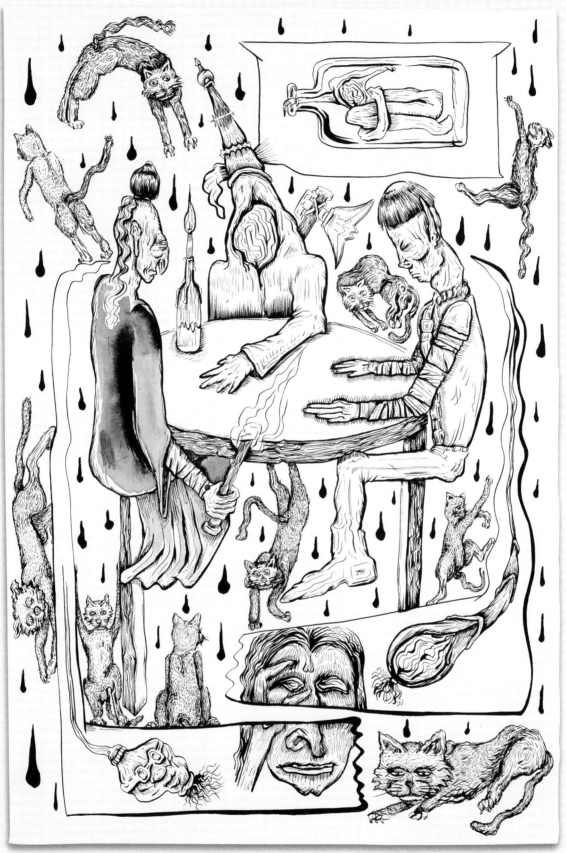

Thugs and Vandals, Charmed By Gorgoroth VI, 2021

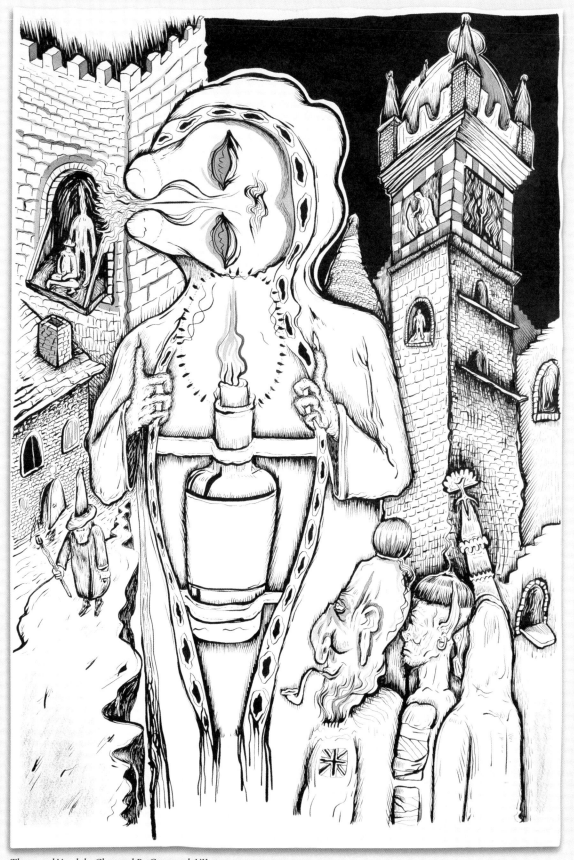

Thugs and Vandals, Charmed By Gorgoroth VII, 2021

Opposite
*Thugs and Vandals, Charmed
By Gorgoroth VIII*, 2021

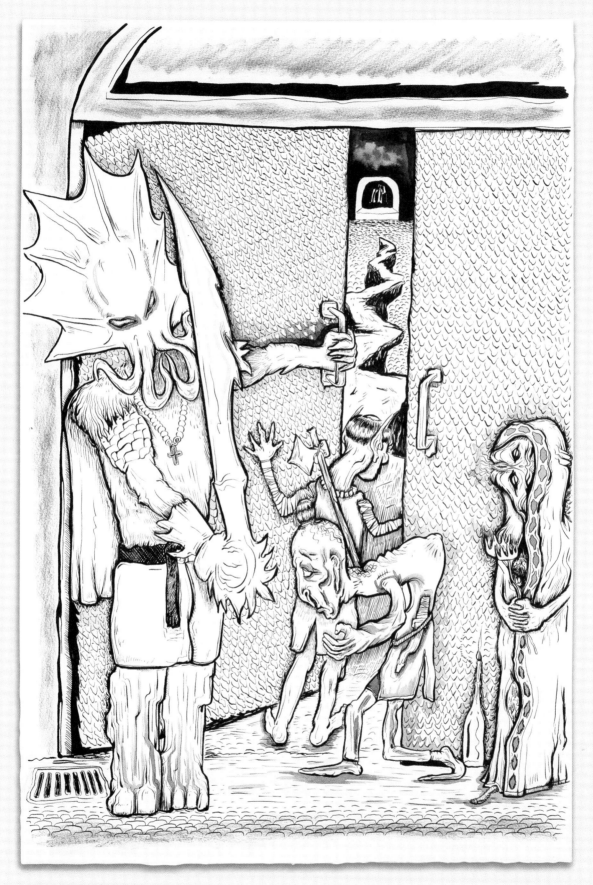

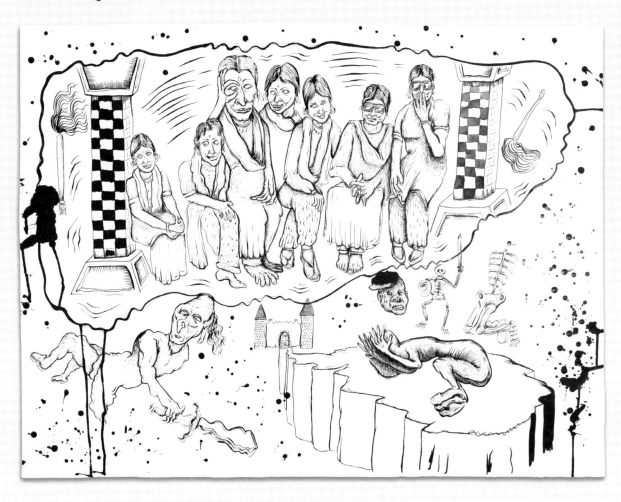

Thugs and Vandals, Charmed By Gorgoroth XIII, 2021

Opposite
Thugs and Vandals, Charmed By Gorgoroth I, 2021

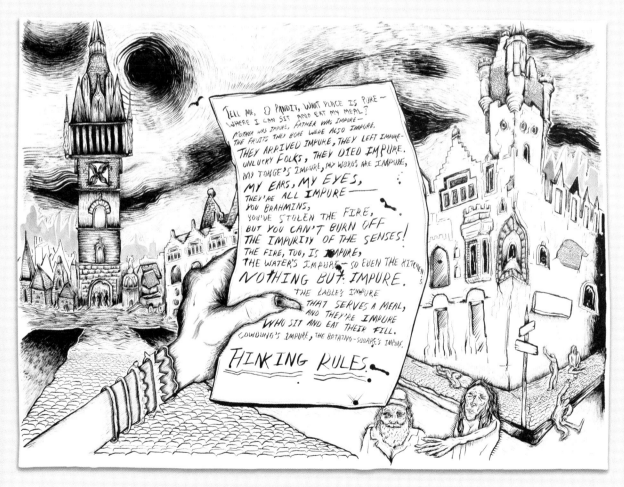

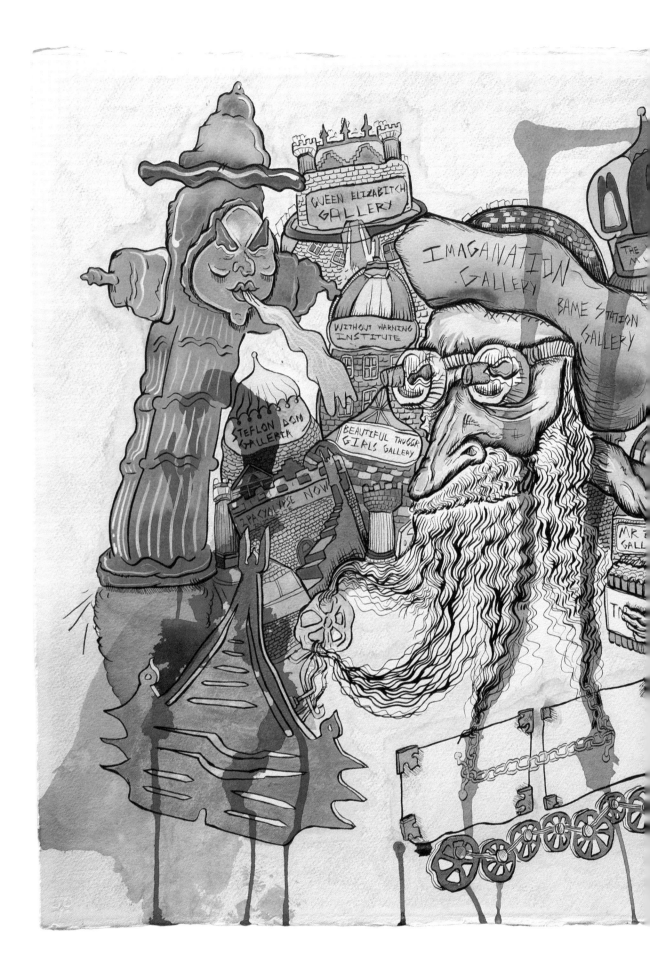

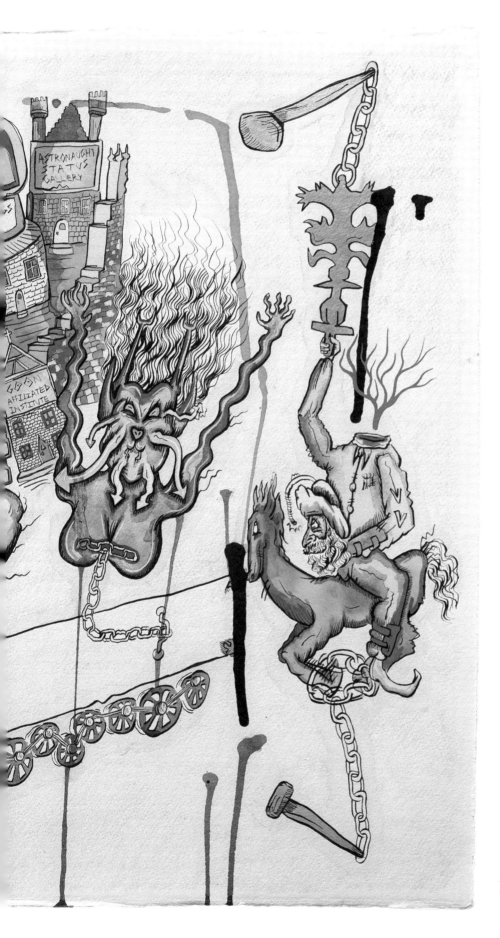

*Harlequin's Penultimate
Confession, 2020*

RIDING SHOTGUN ON THE PANDHALMOBILE

BY HAMMAD NASAR

Hardeep Pandhal's art offers a multiplicity of meanings within forms that may look familiar but that behave in eccentric ways. It is tempting to treat his densely layered, word-heavy drawings; his DIY animations that mix rap, video games and social commentary; and his collaboratively produced music and sculptural objects as puzzles laden with Easter eggs awaiting discovery by devotees of the artist's self-described "Punjabi Gothic weirdness". Tempting, but not especially fruitful, as Hardeep's works are invitations for viewers to journey through them, rather than points of arrival for something as prosaic as an answer or a message.[1]

I would suggest that the artist himself is a fellow traveller on these journeys: that his artistic universe is under construction. Hardeep's world-making is not sketched out in minute detail but is an endless loop of curiosity gone feral – frantic drives through vaguely familiar territory obscured by a blanket of fog, when the GPS has stopped working. There are no maps at hand, and you have to navigate by smell. This essay considers four such excursions, where I have had the chance to ride shotgun.[2]

CHANNELLING A 15TH-CENTURY RAPPER

Hardeep's wall drawing *Purity*, 2021, rendered in Indian ink on the white walls of the Aberdeen Art Gallery for "British Art Show 9", shows a spectral hand emerging from the neck of a standing male figure carrying his own severed head in his hands.[3] Two inverted chevrons on the shirt sleeve, the almost architectural hoops holding the standard-issue black belt in place on trousers that scream khaki despite being drawn in black ink on white wall, and the turban and beard all suggest a uniform-wearing Sikh sepoy – a colonial-era Indian soldier. The head with its vacant eye sockets faces the viewers' left, but their attention is dragged to the right by the text written on a piece of paper held up by the disembodied, other-worldly hand – drawn in a stylistic nod to a comic book version of a genie emerging from Aladdin's lamp. The paper is held in place by a thumb turned eerily

prominent by the hair – itself the subject of varying cultural discourses on purity – growing from its nail. The text inscribed on the "paper" by Hardeep in a mixture of graffiti-esque drips and gothic squiggles starts:

> *Tell me, O pandit,*
> *what place is pure –*
> *Where can I sit*
> *and eat my meal?*[4]

This poetic plea is the beginning of a song by the 15th-century Indian devotional poet Kabir (possibly 1398–1448), a figure whose biography remains resistant to historical certainty despite two centuries of scholarship – Wikipedia, for example, has him living to an unlikely 120 years.[5] Born in Benaras or Kashi (now Varanasi) into a community of illiterate cotton weavers of low social rank (most likely lower-caste Hindus who had converted to Islam), Kabir was a poet, critical thinker and religious figure whose ideas of Truth and social justice delivered in mellifluous verse, and often set to music, have had an outsized cultural influence on the South Asian subcontinent.

Persecuted for his ideas that rejected orthodox Hinduism and Islam, Kabir was forced to flee the religious centre of Benaras for Magahar, where it is said that, when he died, his body disappeared and fragrant flowers appeared in its place. He is now revered as a saint by Hindus and Muslims – both communities maintain parallel sites of devotion. His verse is also quoted in Sikhism's holy book, the Guru Granth Sahib, as it closely aligns with the central tenets of Sikhism, which include: belief in a single universal genderless God; the search for Truth through resisting the "five thieves" of ego, anger, greed, attachment and lust; a union of physical, mental and financial service towards justice and equality; and a central role for song and music as forms of meditation and remembrance. For similar reasons, Kabir is also considered a Sufi.

The lack of historical accuracy around both the figure of Kabir and his work opens up an arena of possibility in which a range of different narratives can be projected in keeping with the

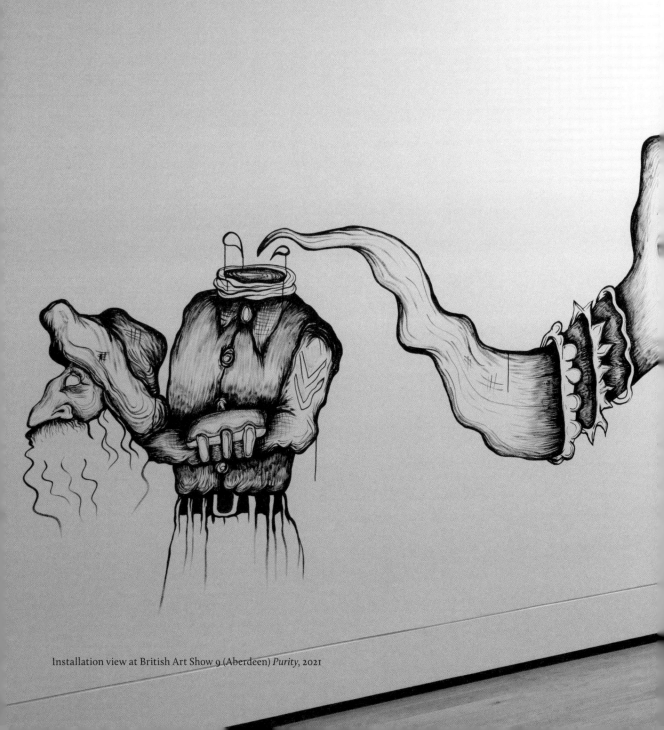

Installation view at British Art Show 9 (Aberdeen) *Purity*, 2021

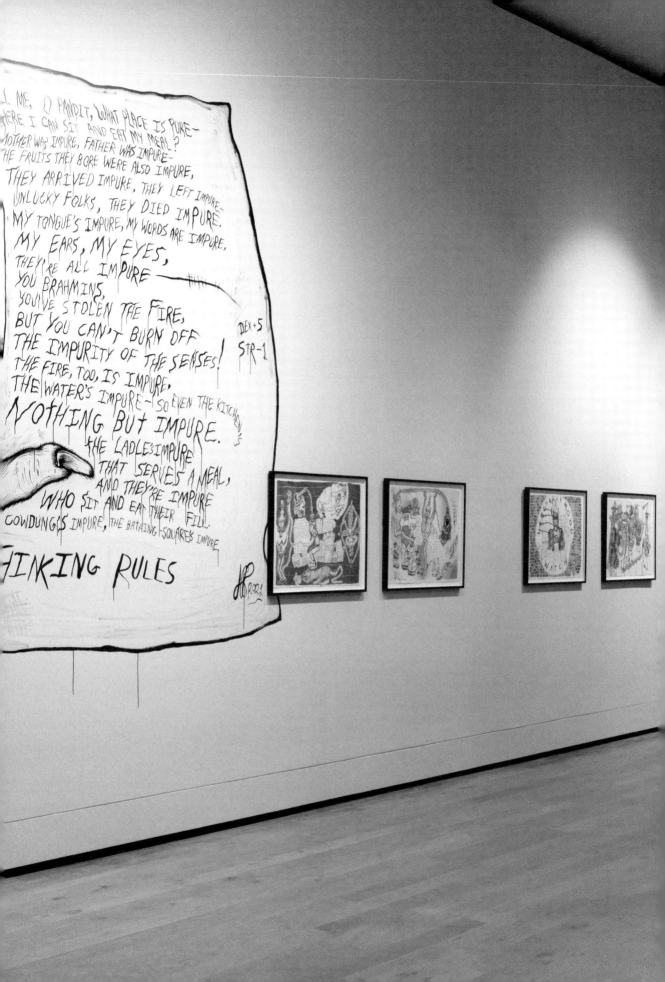

changing desires of communal or nationalist interests. But it also opens up space for fiction – which often does a better job of truth-telling than does an enumeration of facts. This space, for projecting and imputing meaning onto Kabir, makes the poet a generative figure for Hardeep. The annotations of "DEX+5" and "STR-1" – familiar to aficionados as modifiers to the "dexterity" and "strength" ability scores of characters in Dungeons & Dragons and other role-playing games – scribbled on the side of the drawn page in *Purity*, suggest that Hardeep is adopting Kabir as a character that he can channel. The most direct result of this channelling is indicated by the artist's insertion of the words "Thinking Rules" at the bottom of the text in *Purity*. This is Hardeep as Kabir with DEX+5 and STR-1 versioning Kabir's original ending of the song:

> *Kabir says,*
> *only they are pure*
> *who've completely cleansed*
> *their thinking.*[6]

The last verse, with Kabir addressing himself, is a poetic signature commonly deployed by poets in South Asia. "Thinking Rules", the words Hardeep uses to replace this with, is punchier. Written in larger glyphs, with alphabets morphing into each other, it reads like graffiti. Hardeep wants viewers to notice this change. By substituting his own ending for the last verse of the song, Hardeep inserts his own signature at the bottom of the "page". Kabir was most likely illiterate, and his words circulated, initially among the similarly illiterate low-caste Hindu and Muslim weaving communities and then more widely among the mostly illiterate population of India, through oral transmission. Kabir's songs were sung and set to music long before they were written down, possibly generations or even centuries after they were first composed. Singing for social justice and against oppression of the lowly born – what was Kabir if not a rapper of 15th-century India?

INSTITUTIONS AND
THEIR DISCONTENTS

Through channelling the figure and work of Kabir, Hardeep extends an ongoing exploration of his own relationship to the Sikh religion into which he was born but that he never really practised. He does this through cultural expression rather than theological reflection or institutional critique. It is difficult not to see Kabir's poetry, with its simple repetitive structures, reflected and refracted, for instance, in the sardonic lyrics of Hardeep's *Rishi Ritch*, 2021, which uses "I'm so rich... rich, rich, rich, rich, rich..." as a repetitive, rhythmic trope; or engaging with structural oppression due to wealth inequalities – "Inheritance will pay my fees..." – or racial identities "I'm a rich POC, cuz I look like Ranjit Singh...". Ranjit Singh was the first ruler of the Sikh empire.

The opening lines of the lyrics for *Rishi Ritch* are also a tour de force of blunt reflections on the artist navigating academic and art-world structures as a brown person from a working-class background. These same institutions that, in the wake of protests for racial justice triggered by George Floyd's brutal murder in 2020, are now at pains to be, and perhaps more importantly to be seen to be, inclusive.

> *Don't drop names unless it's BAME*
> *I'm looking for BAME hurricanes.*
> *That I can be the first to name*
> *because I have the BAMEst name.*
> *I'm BAMEstorming myself insane*
> *for thesis titles I can claim.*[7]

Squint, and you can see a parallel interest in institutional infrastructure. Kabir's opening plea for a place of refuge, "what place is pure – where can I sit and eat my meal?", is reflected in the eccentric scenes that populate the series of drawings by Hardeep that hang adjacent to *Purity* in Aberdeen. Collectively

"The opening lines of the lyrics for *Rishi Ritch* are also a tour de force of blunt reflections on the artist navigating academic and art-world structures as a brown person from a working-class background"

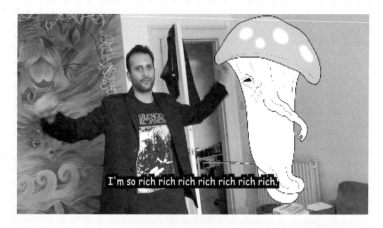

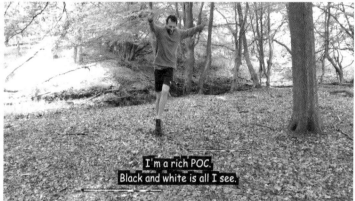

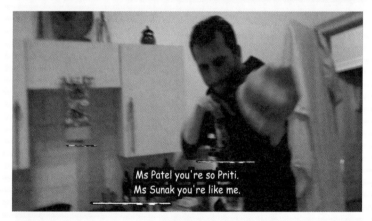

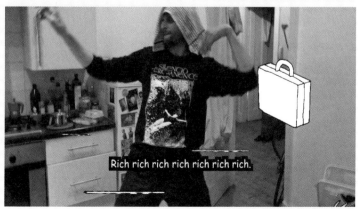

Stills from
Rishi Rich, 2021

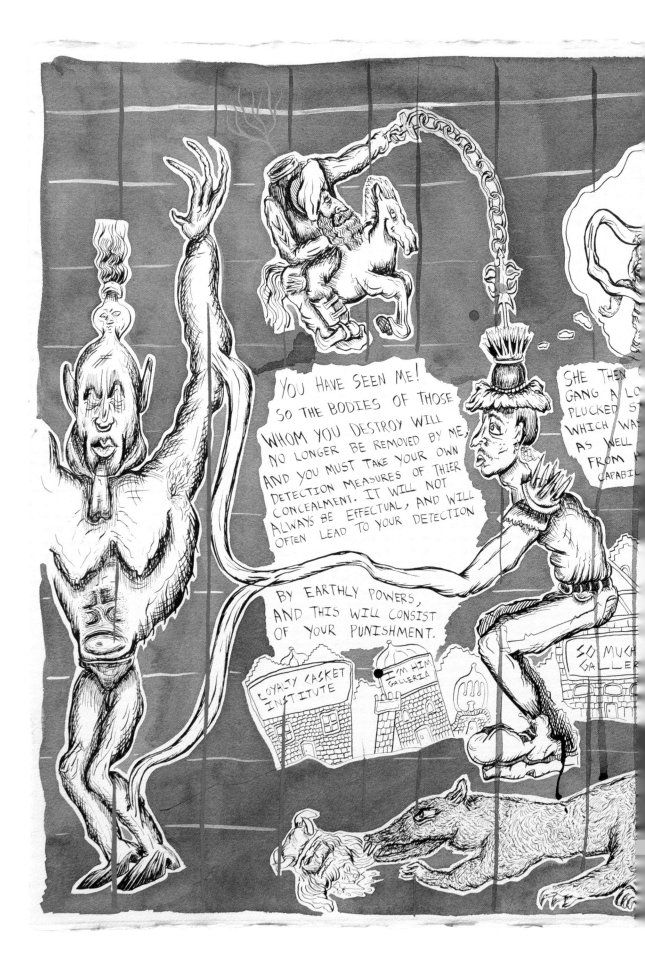

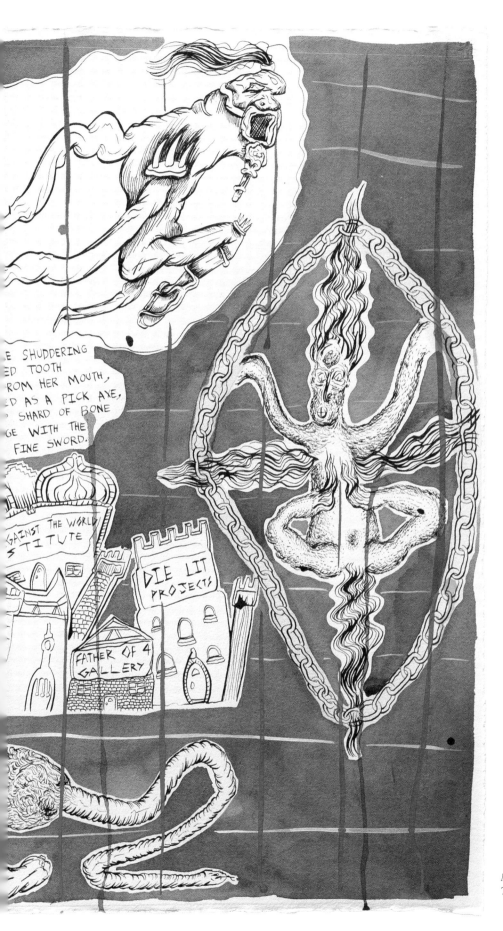

E SHUDDERING
ED TOOTH
ROM HER MOUTH,
D AS A PICK AXE,
SHARD OF BONE
GE WITH THE
FINE SWORD.

GAINST THE WORLD
STITUTE

DIE LIT
PROJECTS

FATHER OF 4
GALLERY

Mango Kushan's Ransacked Tavern, 2020

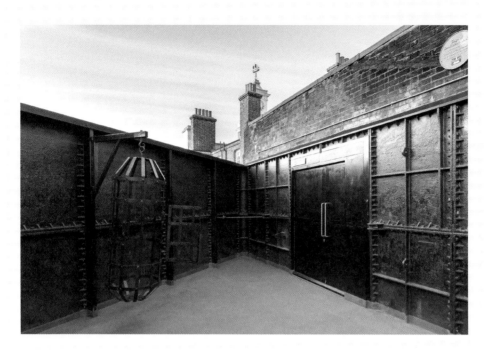

Left and opposite below
Installation view of
Ensorcelled English at
Goldsmiths CCA, 2020

titled *Confessions of a Thug*, 2020, these drawings introduce us to "What a time to be Alive Gallery", "The WRLD on Drugs Project Space", "Father of 4 Gallery", "Me Against the World Institute", "BAME Stations Gallery", "Without Warning Institute" and "Nuthin 2 Prove House".[8] The names of these places may seem whimsical but most of them originate in the titles of rap albums that Hardeep was listening to at that time. Amid the sarcastic humour is an underside of hope. It is in these places where power rests that Hardeep's work brings rap's energy and iconoclastic drive, and the possibility to act – with DEX+5 and STR-1, if needed – to address the role of art schools, galleries and museums as places of "interpretive power".

A concrete manifestation of this drive is *Cage of Unbridled Nuance*, 2020, commissioned by Goldsmith's Centre for Contemporary Art, which was initially shown in the context of an art school and then as part of Hardeep's presentation in "British Art Show 9" at Wolverhampton Art Gallery.[9] The work comprises a suspended steel cage and a customised blue plaque of the sort that mark sites of historical significance in the UK, for example, the former homes or places of work of writers, scientists and thinkers. The cage

evokes the foreboding fantasy world of the cult Japanese video game *Dark Souls*. The plaque, affixed to a red-brick wall of the sort that Hardeep draws repeatedly in the *Confessions of a Thug* series, bears the inscription "Protects users from those in positions of unbridled interpretive power". The plaque carries the controversial flag of the Black Country, where Pandhal grew up, with its chain, depicted to represent the manufacturing heritage of the area, also triggering historical associations with the role of Black Country factories in producing manacles and chains for the slave trade. This very public placement of the cage and plaque in Wolverhampton's main civic art space brings to the surface difficult colonial histories that remain largely absent from the histories taught in UK schools.

A similar undercurrent of defiance is present in the headless sepoy in *Purity*. At the Aberdeen exhibition, the wall drawing was positioned to abut the first framed drawing from the *Confessions of a Thug* series, suggesting a direct connection. The series, in a riot of colour, explores the Indian origin of the word "thug" through the guise of a superhero comic strip featuring a bearded colonial soldier as a headless horseman. It is teeming with dense references to steampunk aesthetics and

John Gardner's novel *Grendel* (named for the first English monster in literature), and it borrows its name from Tupac Shakur's hip-hop group, Thug Life. Hardeep has written about the headless soldier character as an amalgam of the 19th-century Sikh emperor Ranjit Singh, and Baba Deep Singh (see "In Conversation", p 92).[10] The sepoy can also be read as a reference to the designation, by the British, of Sikhs as a "martial race", and by their disproportionate number in the East India Company's forces, and later in the British Indian Army. While these references to Sikh mythology and cultural history suggest cultural specificity, the headless figure is a transcultural and transhistorical motif. Numerous examples abound: the 3rd-century St Denis, one of the patron saints of Paris, reputed to have walked for six miles carrying his own head after his beheading by Roman soldiers; the French philosopher Georges Bataille's *Acéphale*, a secret society and journal founded in 1937 that adopted the headless figure to represent the death of God; and the contemporary headless figures that populate much of artist Yinka Shonibare's sculptural oeuvre. Hardeep sees in this headless figure the emancipatory potential of "becoming headless and more egalitarian in spirit" – a commitment to equality in keeping with the fundamental teachings of Sikhism (see "In Conversation", p 92).

"The plaque carries the controversial flag of the Black Country, where Pandhal grew up, with its chain, depicted to represent the manufacturing heritage of the area, also triggering historical associations with the role of Black Country factories in producing manacles and chains for the slave trade"

HOME IS THE SONGS WE SING AND THE GAMES WE PLAY

Hardeep's worldbuilding, as articulated in a changing series of artist statements and project proposals, centres on his conception of a "Weird Punjabi Gothic" genre, populated by "illiterate mothers, repressed fathers, decapitated bodies, haunting colonial subjects…".[11] There is an emphasis on the familial here, with its accompanying baggage of generational trauma through oppressive regimes (colonial, educational, economic, class), that finds a receptive counterfoil in the caste-bound hierarchies that Kabir challenges:

> *Mother was impure*
> *father was impure –*
> *the fruits they bore*
> *were also impure.*
> *They arrived impure,*
> *they left impure*
> *unlucky folks,*
> *they died impure.*[12]

Kabir's "Purity" is a poem in *The Weaver's Songs*, a compendium of his verse that derives its name both from Kabir's own lineage as a cotton weaver and from his imagining of God as a weaver. In the Aberdeen Art Gallery in 2021, positioned on the other side of *Confessions of a Thug*, were two embellished jumpers made collaboratively by Hardeep and his mother – *Too POC By Mum and Me*, 2017, and *Eye Needle Dick Noodle By Mum and Me*, 2017. Hanging from brackets used to suspend boxing bags in gyms, they also recall the

Cage of Unbridled Nuance

Restored in 2020

Protects users from those in positions of unbridled interpretive power

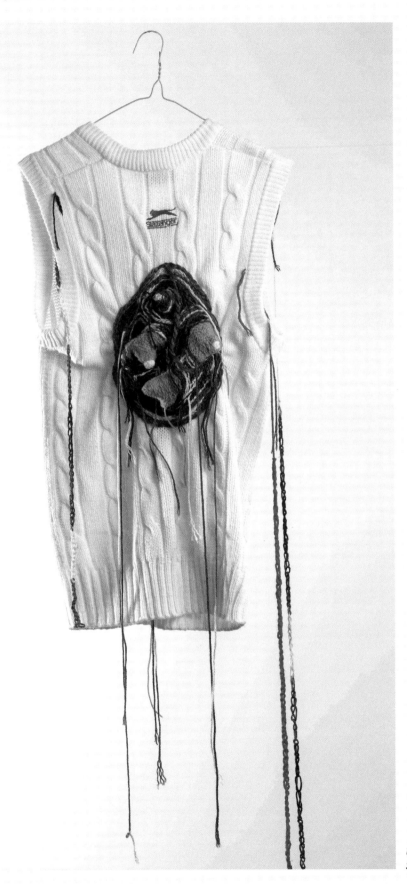

Untitled (The Lord Tebbit Series 5), 2019

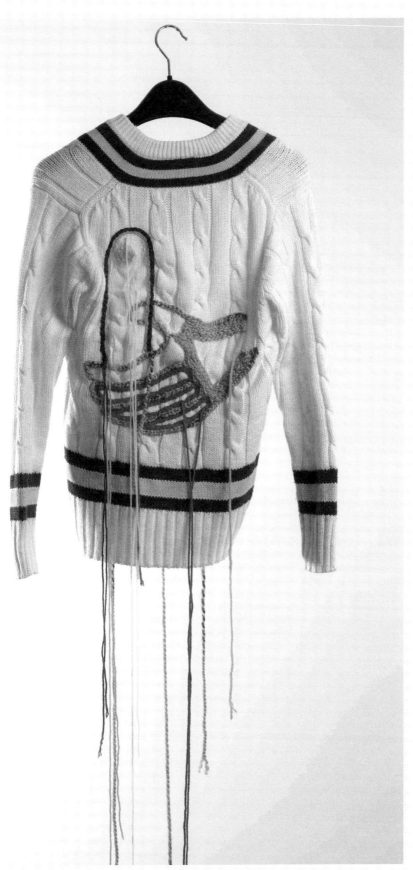

Untitled (The Lord Tebbit Series 7), 2019

hangman's noose and hanged figures left suspended in public squares for their impact as deterrence. Much has been written on this collaborative making as a bonding activity that allows the artist's Punjabi-speaking mother to spend time with her English-speaking son in a common endeavour – often the creation of knitted portraits. *Too POC*, for instance, is Hardeep's tribute to the rapper 2Pac (Tupac Shakur, aka Makaveli). As Pakiveli, Hardeep borrows Makaveli's strategy of inverting racial slurs and using them as a positive. I read this collective act of making as an intergenerational enactment of belonging.

The entangled story of jumpers and belonging takes a different twist in *Untitled (The Lord Tebbit Series)*, 2019, an installation of four cricket sweaters on cheap charity-shop hangers suspended from the ceiling by fish wire at Wolverhampton Art Gallery.[13] Unlike the "Mum-made" sweaters in Aberdeen, these are commercially produced, with prominent labels identifying them as products of venerable English cricket suppliers (Gunn & Moore and Duncan Fearnley, for instance). They are embellished with Hardeep's recognisably excessive knitted illustrations: bulbous forms emerge, and varying lengths of yarn dangle, in the colours of the electric tape (red, orange, green, blue) used to cover tennis balls to give them weight and speed when playing cricket on subcontinental streets.[14]

There is a roughshod symmetry at play here: two are full-sleeved sweaters, two are sleeveless vests; two carry stripes in shades of blue associated with Indian cricket, two bear the green stripes of Pakistan; two carry knitted illustrations on their fronts, two on the back. The most lurid of these is of a batting-gloved hand with a masturbatory hold on an erect penis. This is not a sweater to wear to dinner at the hallowed Long Room of Lord's Cricket Ground, but its inflammatory intent is probably directed at a different lord – Lord Norman Tebbit, Conservative politician and erstwhile member of Margaret Thatcher's cabinet. Tebbit coined the "Tebbit Test" or "Cricket Test" as a measure of the integration of Britain's population of South Asian or Caribbean heritage, claiming that, for these communities, showing support for cricket teams from India, Pakistan or the West Indies in matches played in England was disloyal and suggested a worrying lack of assimilation.

Cricket is a culturally loaded trope. It may have originated in medieval England, but the spiritual heart of the contemporary game is now firmly in South Asia and its financial engine in India, while its administrative home left the Marylebone Cricket Club at Lord's many years ago for tax-free living in the United Arab Emirates. Cricket's journey, from an imperial export to the present day, where a former colony now calls the shots, is not linear.[15] For a sport played by a privileged minority in England, cricket has an outsized cultural impact. It has infected the English language: "it's not cricket" is an admonishment for injustice, for instance, and "played a good innings" is admiration for a successful career or for leading a full life. Cricket has become an extended metaphor for life, and first featured in Hardeep's work as "Silly Point" – his recognisable bearded sepoy, crouching in cricket whites.

In 2021, thanks to the whistle-blowing efforts of Azeem Rafiq, a Pakistan-born Yorkshire cricketer, English cricket showed its ugliest side. Its direct impact was the suspension of the Yorkshire Cricket Club from hosting international cricket on account of its being institutionally racist; and a 2022 report from the Digital, Culture, Media and Sport (DCMS) select committee that found "deep-seated" racism within the sport. It recommended a

"Hardeep's cricket sweaters were made before the Azeem Rafiq racism scandal broke, but, like most powerful art, they have the capacity to summon new readings, bringing different times and events into a critical and discomforting dialogue"

series of measures for the England and Wales Cricket Board to take to clean up its act, and ordered it to report on progress or lose its government funding. But the biggest price so far, for calling out racism, seems to have been paid by Rafiq himself, not just in terms of cricketing dreams thwarted but having to move his family out of the UK for safety reasons.[16]

Hardeep's cricket sweaters were made before the Azeem Rafiq racism scandal broke, but, like most powerful art, they have the capacity to summon new readings, bringing different times and events into a critical and discomforting dialogue. It is tempting to read the cricketer's brown and bearded face into one of the knitted portraits. A prime candidate for one of the remaining portraits is KS Ranjitsinhji (known popularly as Ranji), the first Sikh to play cricket for England, and possibly the game's first global superstar, who went on to rule the princely state of Nawanagar (1907–33). Ranji was known for his unorthodox technique and fast reactions, and for inventing the leg glance, a shot that uses the pace of the ball in a well-timed deflection to score runs rather than using oppositional force – a method in keeping with Hardeep, aka Pakiveli.

Hardeep's cricket sweaters, with their tangled and dangling threads, lurid embellishments and idiosyncratic references, are Britain's entangled colonial histories made yarn.

HOLDING SPACE AND PUSHING HANDS
HEADLINES (Withdrawn Artist Reluctantly Participates In Exhibition), or simply *HEADLINES*, 2022, was a site-specific wall drawing for Manchester Art Gallery, as part of "British Art Show 9".[17] The largest city of the four that the show travelled to, Manchester ended up hosting its smallest iteration because more than half of the artists withdrew in protest at the external pressure to silence calls for Palestinian solidarity in association with a prior exhibition at the city's Whitworth Gallery.

The process of the group discussions held over Zoom and email – involving 47 artists, complex positions and multiple points of view

– does not lend itself to a pithy summary from a single point of view.[18] But this context is a necessary backdrop to consider *HEADLINES* as this text's final excursion.

HEADLINES is a series of painterly squiggles in thin enamel paint whose visual and conceptual references and meanings are unpacked with great precision and a gentle humour in the label text by Hardeep that accompanied the wall drawing and that forms an essential part of it:

> *Inspired by actual events, Hardeep Pandhal works with extremely rare images and voices to transform feelings of disinheritance and disaffection into generative spaces that bolster interdependence and self-belief. The undulating white lines in this wall painting echo others that appear in his drawings and animations over the last decade, most obviously the beards in his drawings of British Sikh soldiers. During this time, Pandhal has sensed a genuine struggle amongst many cultural opinion formers to translate his work into statements and eye-grabbing headlines without severely undermining his work. Simultaneously, he has observed a direct correlation between the low number of headlines his work has generated with the high number of head lines appearing on people's foreheads when attempting to interpret his art. HEADLINES (Withdrawn Artist Reluctantly Participates In Exhibition) celebrates this observation with the first incarnation of what he believes will amount to a highly significant body of mature and painterly lifeworks exploring the idea of the headline in both its most folded and expanded sense.*

A statement from Irene Aristizábal and myself, as curators of BAS9, was prominently positioned at each of the exhibition's venues in Manchester in support of all artists in the show, those who had withdrawn from the Manchester iteration and those who had chosen to exhibit. The statement also articulated our commitment to the exhibition space being one capacious enough to hold difficult conversations. At the Whitworth and Manchester Art Gallery there was a Reading Room at the entrance of the

Installation views at British Art Show 9 (Manchester)
Headlines (Withdrawn Artist Reluctantly Participates in Exhibition), 2022

BAS9 exhibition with a place to sit, read and discuss publications that explored the complex histories of the Palestine/Israel conflict and the political and civic possibilities of art spaces. I see *HEADLINES* in artistic dialogue with this institutional attempt to hold space for difference and dissent. And it did so at the very centre of the exhibition, amid other artworks.

In an interview with the artist and critic Morgan Quaintance, Hardeep appears to distance himself from the realm of politics.[19] But to my mind his work is deeply ingrained in what, the sociologist and public intellectual, Stuart Hall called a "political imaginary".[20] I would argue that for Hardeep, as for Hall, politics is a field not merely of representation but of action; where, as per the tenets of Sikhism, the "physical, mental and financial" are all in play.

I read politics in Hardeep's choice of mediums: the wall drawing (close kin to that medium par excellence of social engagement, the mural); the home made video for YouTube; DIY rap that moves on SoundCloud; collaborative knitting with his mum; or the modest-scaled drawings that can be completed on the kitchen table. This is not an aestheticisation of poor material but a radical egalitarianism made possible by "losing one's head".

But above all, I read politics in Hardeep's attitude. In his 2Pac aka Makaveli-like acceptance of racial slurs and negativity, and attempts to transform it; to make it generative. I read *HEADLINES* as this tendency's most recent example – where, in the manner of his participation, he held space for those who withdrew.

The Tai Chi exercise of "pushing hands" privileges the idea of "listening" and "yielding" to an attack rather than opposing it with force. The objective is to meet incoming aggression not with strength but with softness; moving *with* the force to allow it to spend itself or to redirect it (like Ranji's leg glance).

Pushing hands while driving seems inadvisable. But what if the act of driving itself is pushing hands? In that case, the best place to ride on the Pandhalmobile is shotgun.

Endnotes

1 I am addressing the artist by his given name, Hardeep, rather than employing the distancing device of using the family name in recognition of my partisan position as someone who has collaborated with Hardeep on multiple projects.

2 As co-curator for "British Art Show 9", 2021–22, I worked directly with Hardeep on four different presentations of his work in Aberdeen, Wolverhampton, Manchester and Plymouth.

3 *Purity*, 2021, was an ephemeral site-specific commission for the opening iteration of "British Art Show 9" at Aberdeen Art Gallery, 10 July – 10 October 2021.

4 Dharwadker, Vinay, trans., "Purity" in *Kabir: The Weaver's Songs*, Delhi: Penguin Books India, 2003, p 124.

5 See Dharwadker, Vinay in "Introduction" to *Kabir: The Weaver's Songs*, p 24, and www.en.wikipedia.org/wiki/Kabir

6 "Purity" in *Kabir: The Weaver's Songs*, p 124.

7 Hardeep Pandhal; see www.colomboscope.lk/hardeep-pandhal, accessed 14 November 2023.

8 All quoted texts are taken from the *Confessions of a Thug* series of drawings, 2020.

9 First shown at *SOLOS* at Goldsmiths Centre for Contemporary Art, 18 September – 13 December 2020. Subsequently shown at "British Art Show 9" at Wolverhampton Art Gallery, 22 January – 10 April 2022.

10 See Pandhal's text on this, under video, at www.colomboscope.lk/hardeep-pandhal, accessed 14 November 2023.

11 Hardeep Pandhal, *Whoever Heard of a Tolkien Artist?* – unpublished artist statement, December 2022.

12 "Purity" in *Kabir: The Weaver's Songs*, p 124.

13 "British Art Show 9" at Wolverhampton Art Gallery.

14 It is this innovation that has allowed a largely poor South Asian populace to play a game increasingly confined to the fee-paying students of elite schools in England, the land of cricket's birth.

15 For more on cricket's imperial past see Nasar, Hammad, "Rock, Paper, Scissors: Notes on Play", *Rock, Paper, Scissors: Positions in Play*, H. Nasar, ed., Abu Dhabi & Milan: UAE National Pavilion & Mousse Publishing, 2017, p 18.

16 For a summary of key events in this story, see www.bbc.com/sport/cricket/63956614, 13 December 2022.

17 "British Art Show 9" at Manchester Art Gallery. Manchester was one of the four cities that "British Art Show", organised every five years by Hayward Gallery Touring, travelled to.

18 As co-curator of BAS9, I was a participant in these discussions.

19 Morgan Quaintance and Hardeep Pandhal's conversation can be accessed at: www.studiovisitshow.com/2018/02/08/hardeep-pandhal/, accessed 14 November 2023.

20 Hall, Stuart, 'Jeremy Deller: Joy in People, 2012' in *Fifty Years of Great Art Writing*, London: Hayward Gallery Publishing, 2018, p 440.

Opposite
Rishi Rich (lyric sheet), 2021

RISHI RITCH

DON'T DROP NAMES UNLESS IT'S BAME
I'M LOOKING FOR BAME HURRICANES
THAT I CAN BE THE FIRST TO NAME
BECAUSE I HAVE THE BAMEEST NAME

I'M BAMESTORMING MYSELF INSANE
FOR THESIS TITLES I CAN CLAIM
MY BRAIN FEELS MORE INANE
FROM PURCHASED ACADEMIC CLAIMS TO FAME

THE SCHOOLHOUSE THAT I TEACH IN
HAS MY NAME ACROSS ITS GILTED FRAME
ALL ACROSS ITS GUILTY FRAME
MY NAME WRITTEN IN BLOODY STAINS

I ARRIVED TOO EARLY
AND THE PANEL IS NOT READY
I'M LEANING FORWARD ON MY SEAT
AND SMILING SO INCESSANTLY

I PISSED ALL OVER MY DEGREE
DON'T STAND UP REMAIN SEATED PLEASE
AND TAKE A LOOK AT MY CV
BUT CLOSER THROUGH SOME LENSES PLEASE

NOW SEE THE FOOTNOTES STUCK TO ME
STUCK UNDERNEATH DEAD REFEREES
LIKE AMPUTATED PIGEON FEET
ARE STITCHED BELOW THE MAIN BODY

LET'S FOLLOW IN THEIR FOOTSTEPS
AND HOP OVER TO STAFF BISCUITS PLEASE
WITH COCONUT IN THEM
I'VE GOT A BOUNTY OVER PHDS

AND PLENTY OF HARDEEP IS WHAT IT STANDS
FOR WHEN IT'S ON ITS FEET
STANDS FOR WHEN IT'S ON ITS FEET
STANDS FOR WHEN IT'S ON ITS FEET

RICH RICH RICH RICH RICH RICH RICH
I'M SO RICH RICH RICH RICH RICH RICH RICH

I'M SO RICH
I'M SO RICH

RICH RICH RICH
RICH
I'M SO RICH RICH RICH
RICH RICH RICH
I'M SO RICH RICH
RICH RICH RICH
I'M SO RICH RICH
RICH RICH RICH

RICH X 31

I'M SO RICH
IN A DITCH
I'M A LICH
FILTHY RICH
FINALLY RICH
FINALLY LICH
RISHI RICH

I'M A LICH CAN'T YOU SEE
IN A DITCH BENEATH SOME STICKS
RUB THOSE STICKS
MAKE IT LIT
I'M A RICH
MAKE ME RICH

I'M A RICH POC
BLACK AND WHITE IS ALL I SEE
CCTV'S WHERE I LIVE
BLACK AND WHITE IS ALL I SEE

I MAKE MONEY OVERSEAS
GETTING RICH OFF SYMPATHY
I LIKE TO GET ON MY KNEES
PRETEND I GOT NO MONEY PLEASE

MS PATEL YOU'RE SO PRITI
MS SUNAK YOU'RE LIKE ME
WON'T YOU BOTH MARRY ME
AND EXTEND MY FAMILY TREES

HERITANCE WILL PAY MY FEES
SHOPPING TREES AND BUBBLE TEAS
CALL IT SERENDIPITY
WHEN I GET RICH OFF PITY

I'M A RICH POC
'CAUSE I LOOK LIKE RANJIT SINGH

I'M A RICH POC
SARDONIC HARMONY
I'M A RICH POC
SARDONIC HARMONY

RICH RICH RICH RICH RICH RICH RICH
I'M SO RICH RICH RICH RICH RICH RICH
RICH

I'M SO RICH
I'M SO RICH

RICH RICH RICH RICH
I'M SO RICH RICH RICH
RICH
RICH RICH RICH RICH RICH RICH RICH
I'M SO RICH RICH RICH RICH RICH RICH
RICH

RICH X 31

Opposite
Money Grows on Family Trees, 2018

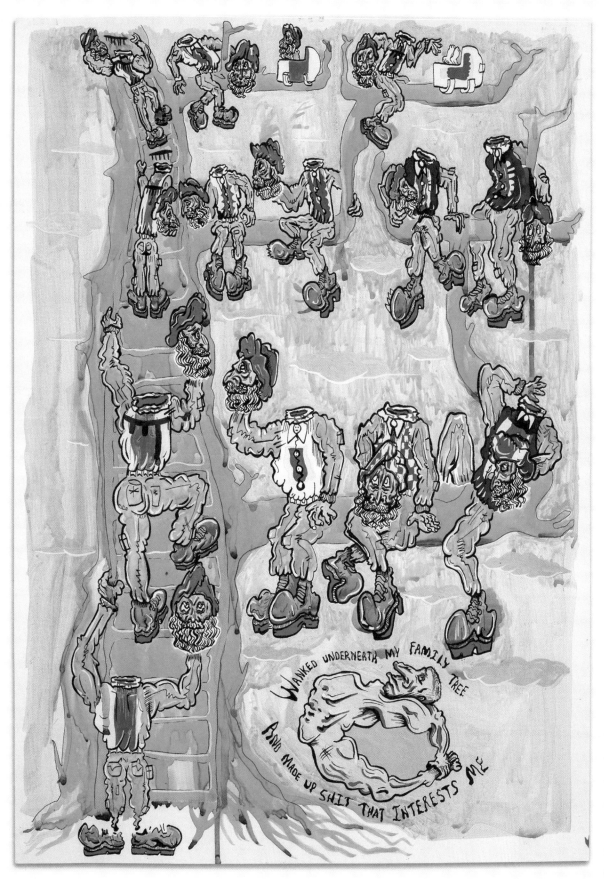

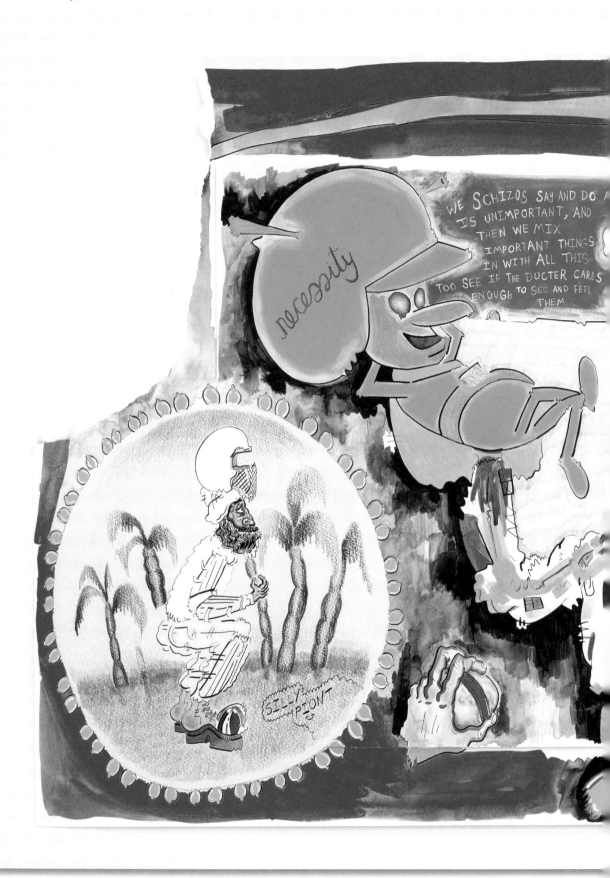

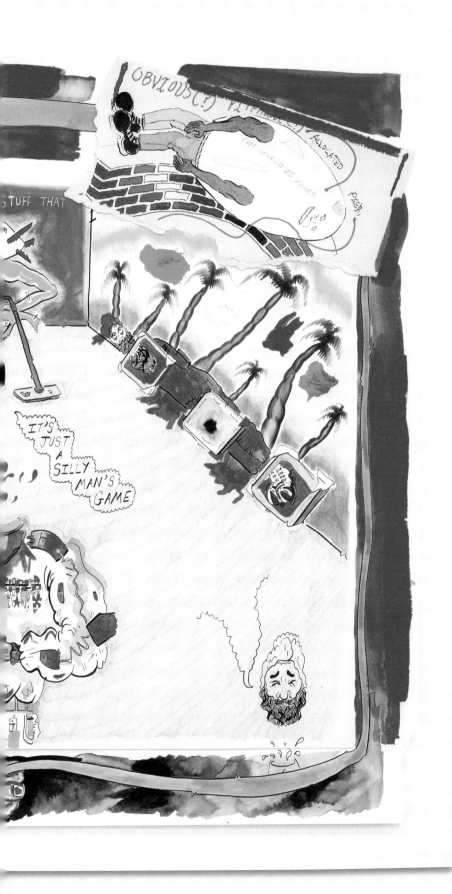

Silly Point, 2014

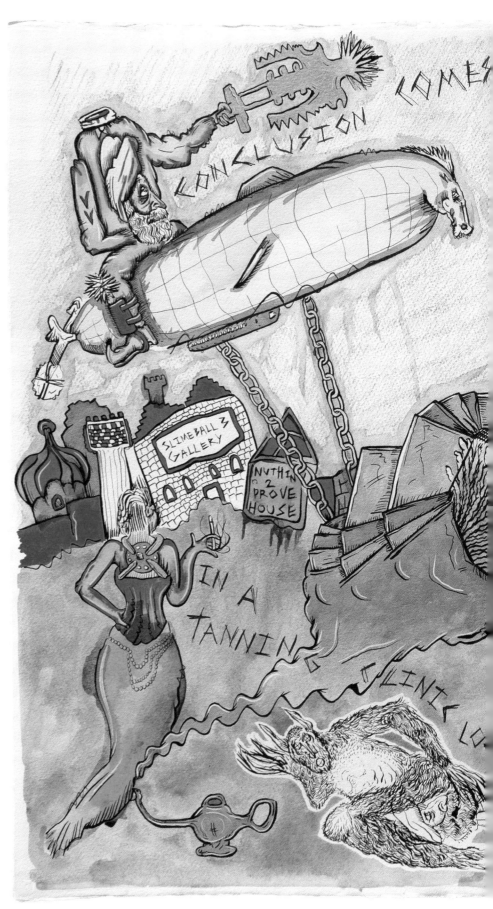

Descending Selkie's Staircase
(Psychologically), 2020

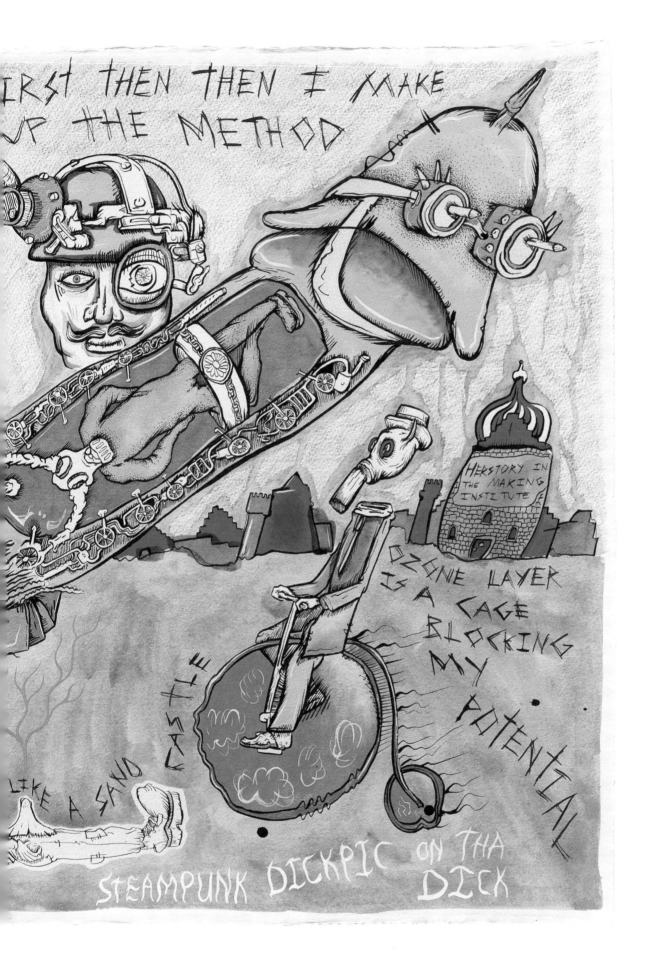

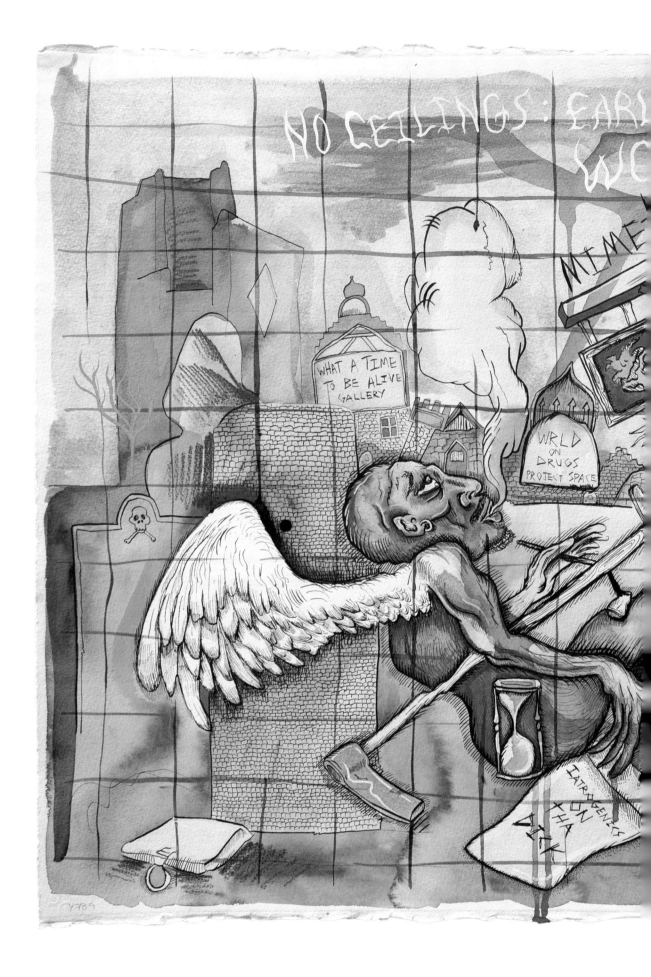

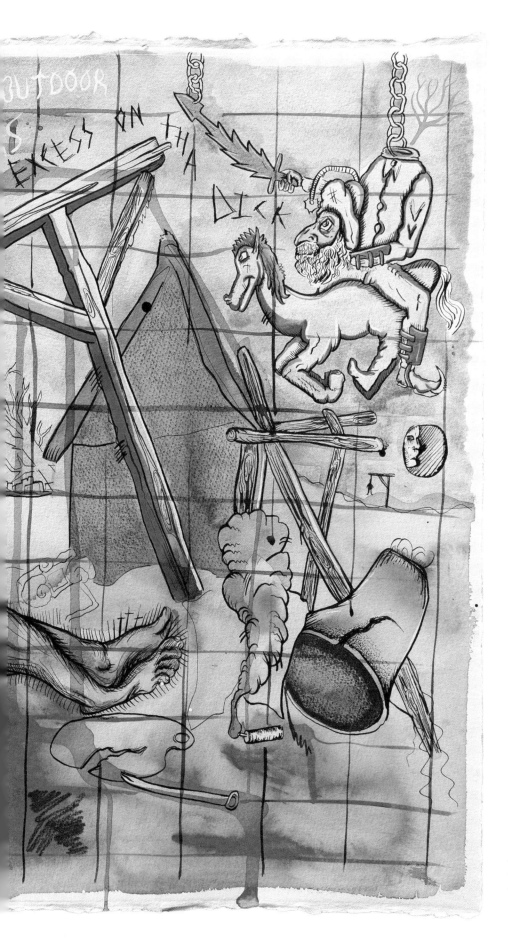

Deflecting Swarthy Reflections From Bog-Water-Upon-Heaven, 2020

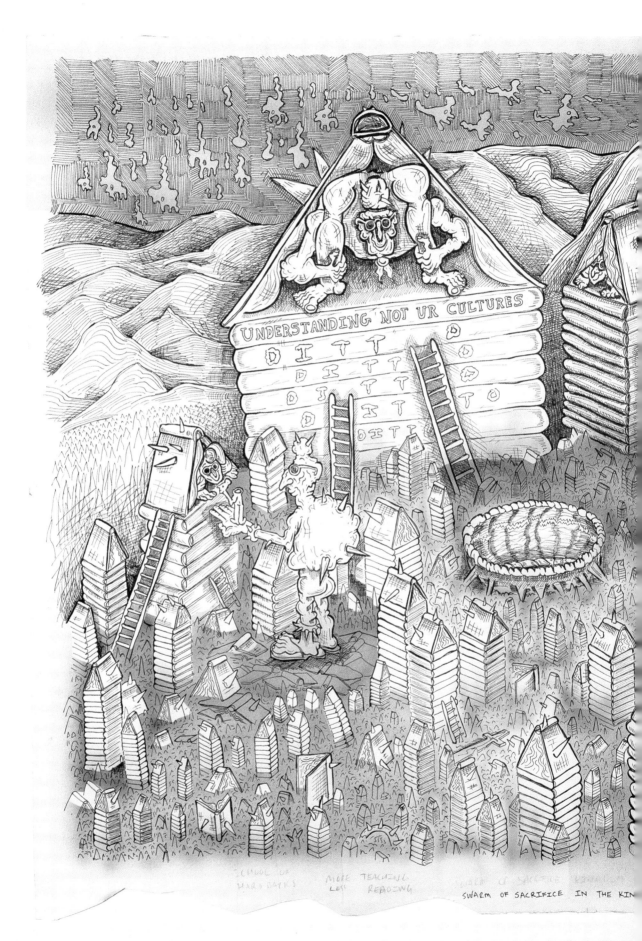

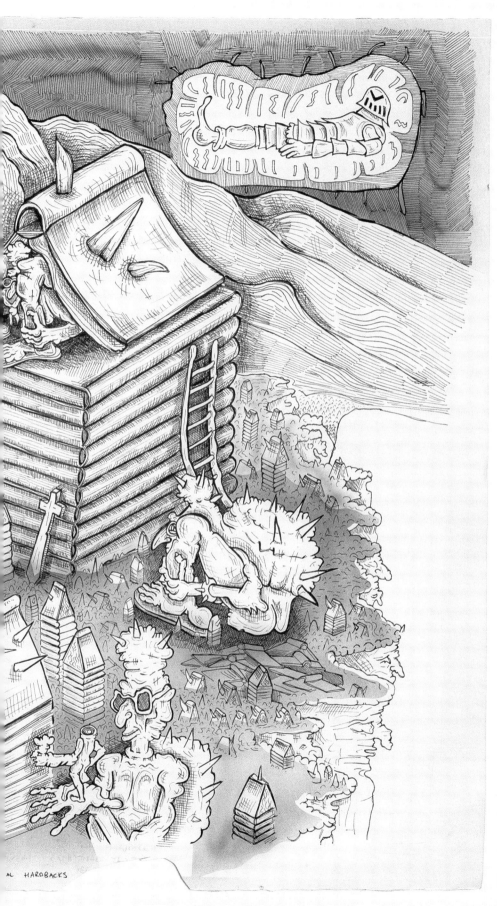

AL HARDBACKS

Swarm of Sacrifice, 2023

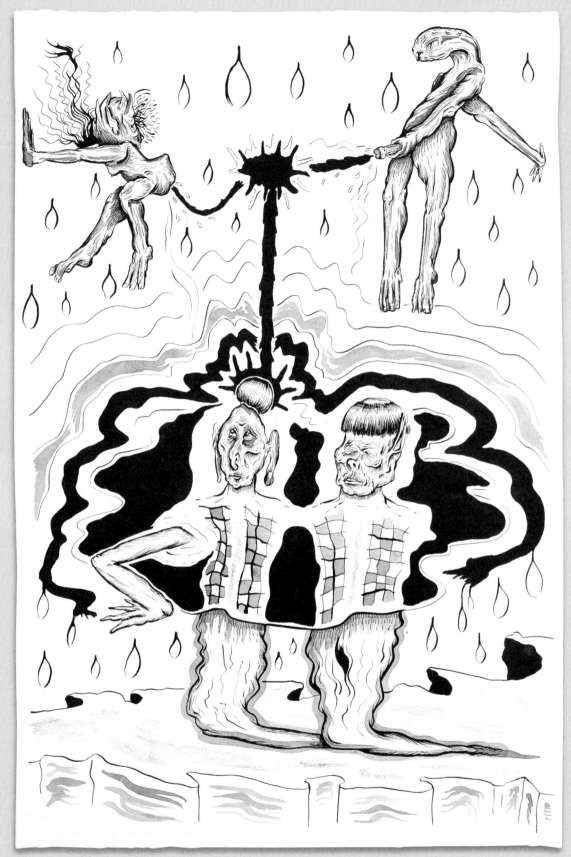

Thugs and Vandals, Charmed By Gorgoroth II, 2021

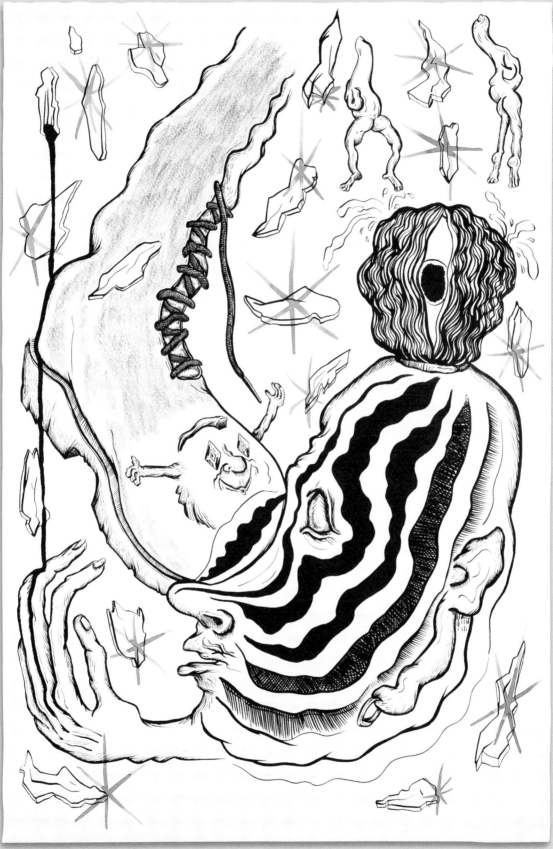

Thugs and Vandals, Charmed By Gorgoroth XII, 2021

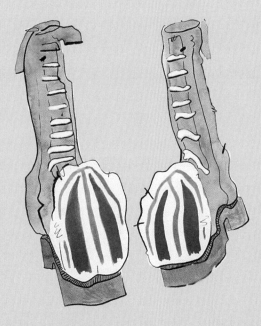

Opposite
An Unexpected Party 1, 2023

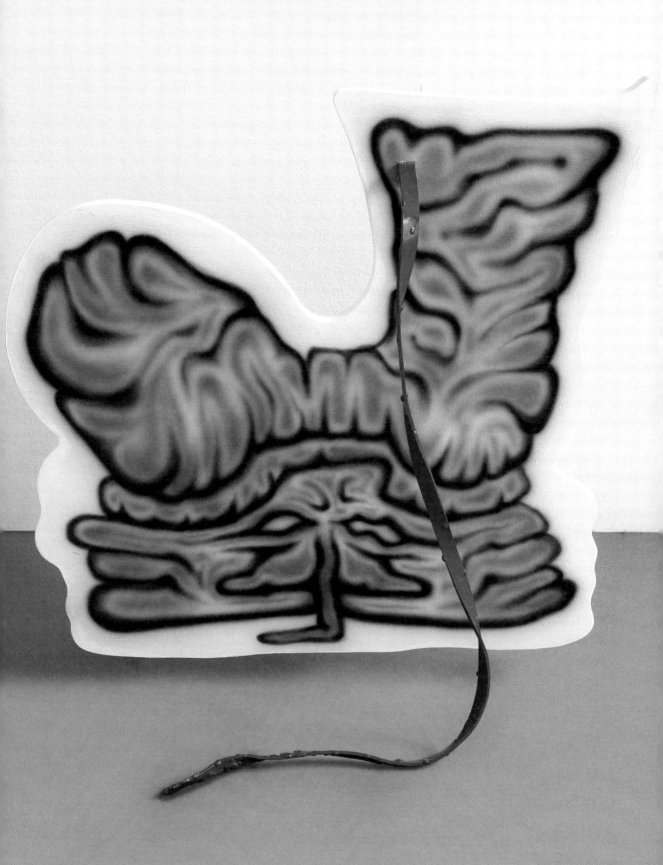

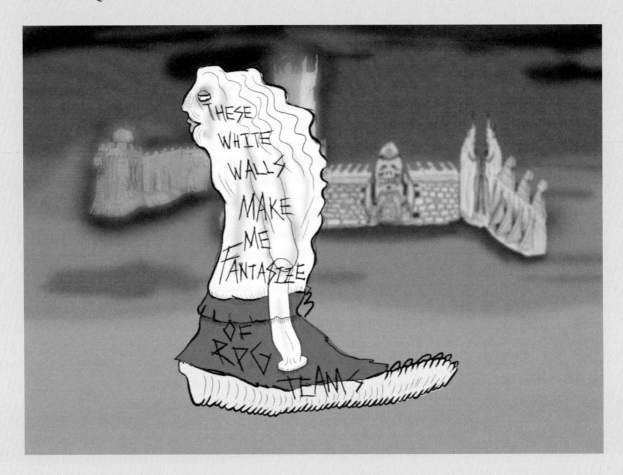

Still from *BAME of Thrones (Trailer)*, 2019

Opposite
Still from *A Nightmare On BAME Street*, 2018

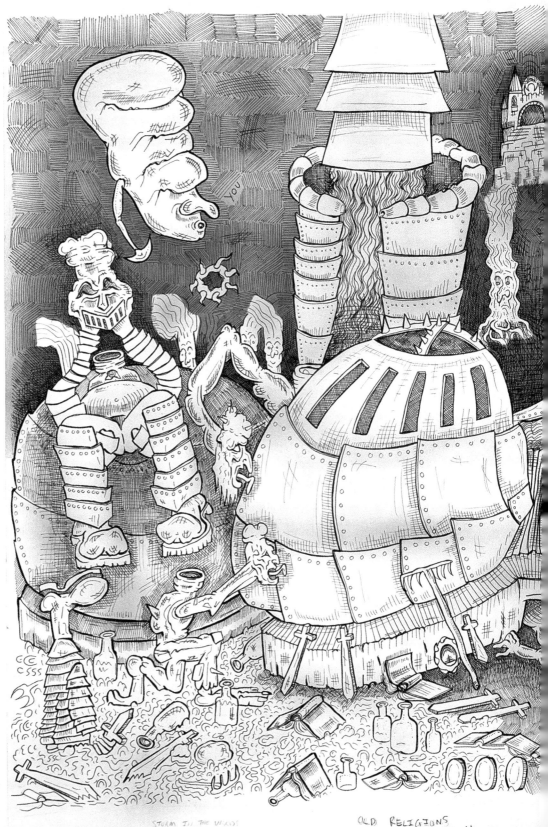

STORM IN THE WOOD

OLD RELIGIONS,
NEW MYTHS. YOU CANNOT R

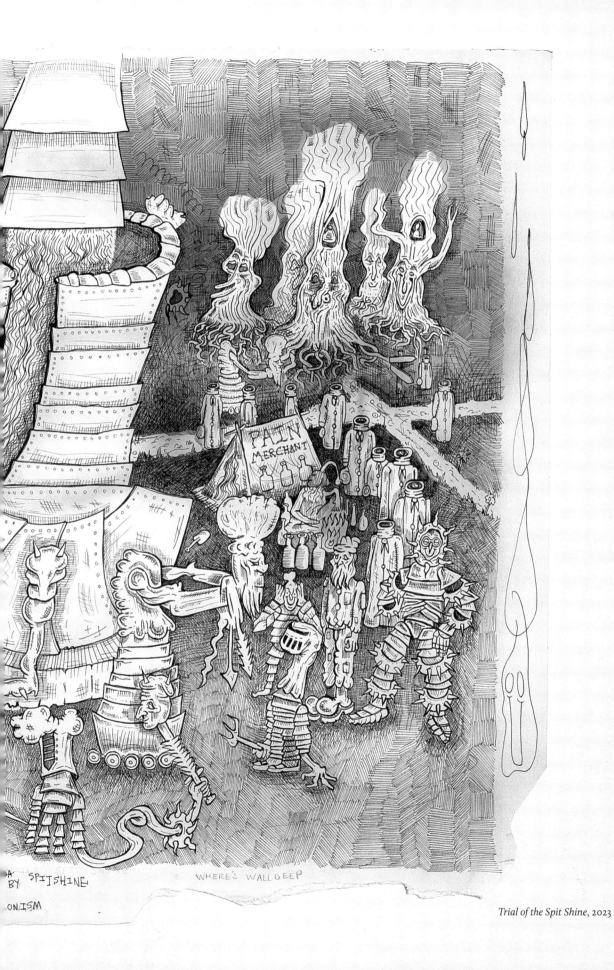

Trial of the Spit Shine, 2023

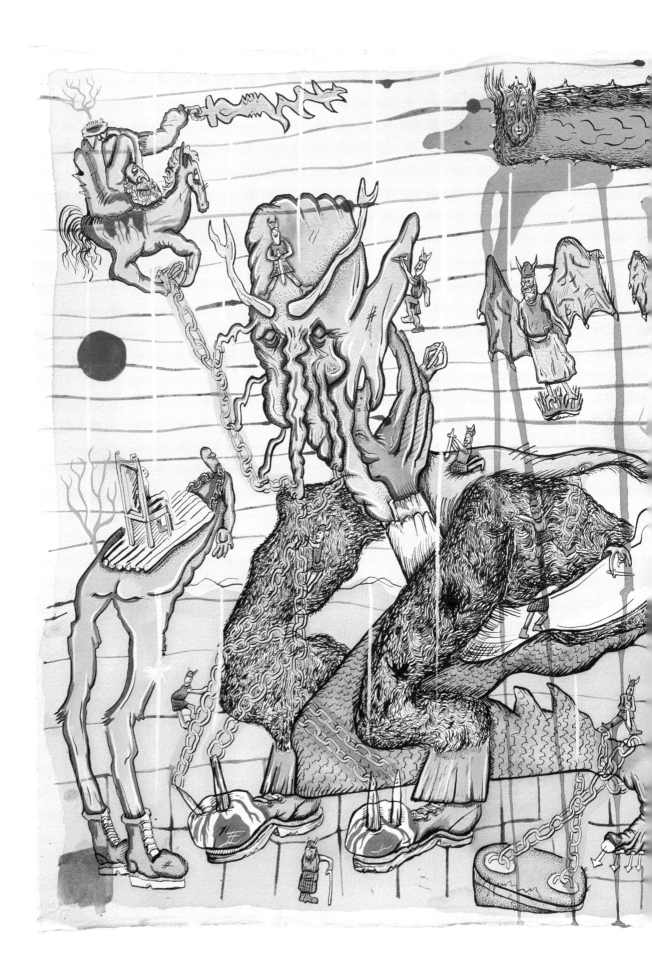

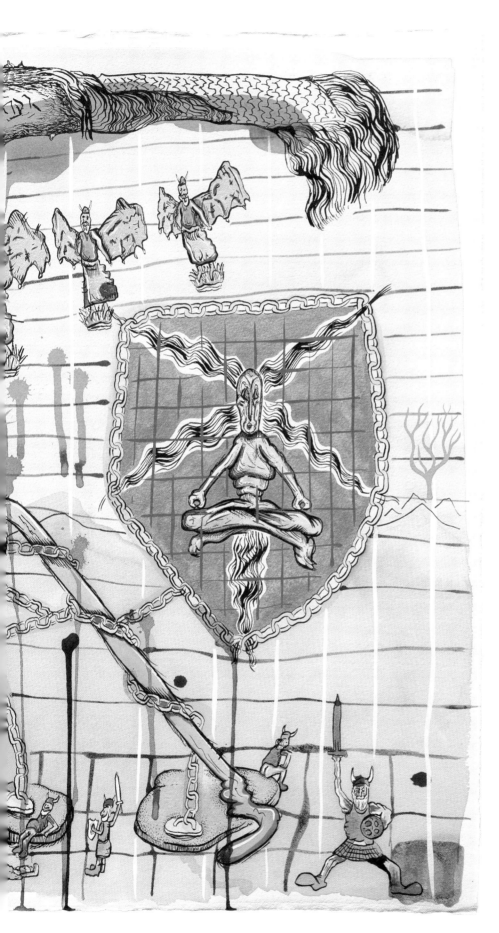

Spectral Scripts Reluctantly Festoon Tantric Dungeon, 2020

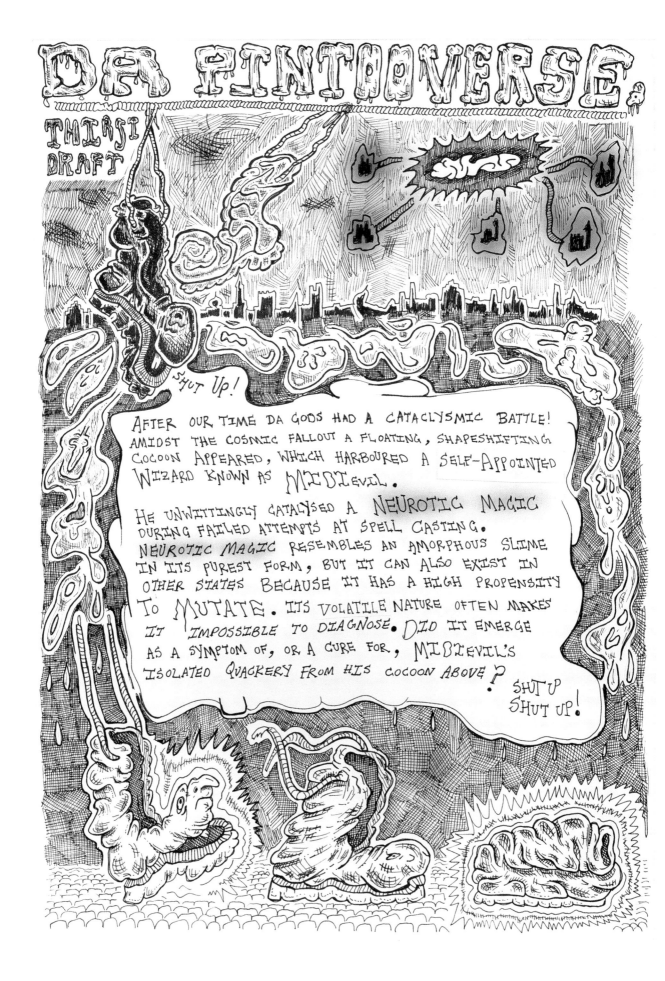

Opposite
Pintooverse Comic Intro (Page 1), 2023

IN CONVERSATION: HARDEEP PANDHAL AND DAVID STEANS

THE BRITANNIA HOTEL, MANCHESTER, NOVEMBER 2022

D. Right, so. What did you learn from being our virtual Dungeon Master during lockdown? This was also the first time you'd ever played [Dungeons & Dragons], right?

H. The Dungeon Master? I was struck by how each player had a different perspective of the scenario I was describing. I guess that's to be expected, when you think about it. Like, how much the players' interpretations affect your worldbuilding?

D. Recently you have begun to describe your work in terms of worldbuilding. In relation to art practice that is influenced by or is in itself some form of worldbuilding, do you think there might be a critical opportunity in that dynamic, where all the participants are experiencing the game differently from one another?

H. I believe so. It encourages collective negotiation, decision making and ultimately a sense of shared agency, which is particularly useful in a socially conscious art practice.

D. Useful for you as the Dungeon Master/artist? Or for the participants/players/audience? Who are also kind of collaborative story-makers, right?

H. Useful for both me the artist and me the Dungeon Master. I can only pray that it's useful for the participants/players/audience. I like the phrase "collaborative story-makers" because I often see life as one big social dungeon just waiting to get mapped!

D. I feel like we're in a social dungeon right now!

H. Ha! This is a very dank bar in what used to be a grand hotel…

D. So, how did this adoption of worldbuilding within your work and thinking come about? And is there a specific project that epitomises the shift? In other words, what's the world?

H. I believe the shift happened in a body of work I started in 2021, which retold the story of a brown man getting into a scrap at a black metal gig. I presented it in the mode of a Sword and Sorcery adventure, across drawing, writing and music. I read it as a superhero genesis story because the brown man unlocks powers after being kicked in the head.

D. So you're not allowing the narrative to just end within the confines of that project, the parameters of which were defined externally, i.e. by an institution?

H. Correct! I had free rein to produce whatever I wanted when starting the narrative. This was after years of making work that fulfilled, or unfulfilled [laughs], short-term agendas for institutions. I've decided to stay in that particular Sword and Sorcery world for now and I've given it a name. I call it the Pintooverse, from a fake name my dad sometimes used when communicating with strangers. So, when ordering a taxi, he would say his name was Mr Pintoo. I never knew why he did this but I can't help but imagine Mr Pintoo's summoning as a symptom of being an outsider. It was like a persona he adopted to help him dress the part, or a disguise to infiltrate unfamiliar places – like an imaginary body double. That dreadful yet invigorating sense of entering the unknown is something I consciously explore in the Pintooverse. I'm also trying to articulate the sense of a constructive assimilation within a parallel world, or the idea of finding hope in rejection or futility. This trajectory grows the more I confront unsettling memories or engage with ideas of weirdness.

D. During your 2021 interview with Peter Kennard he says, in response to your work, that he's "always felt the most optimistic thing is to engage with the actual struggle, not to show some utopian end to it, which is not interesting, not powerful".[1] Could you elaborate on this? On finding hope in hopeless imagery?

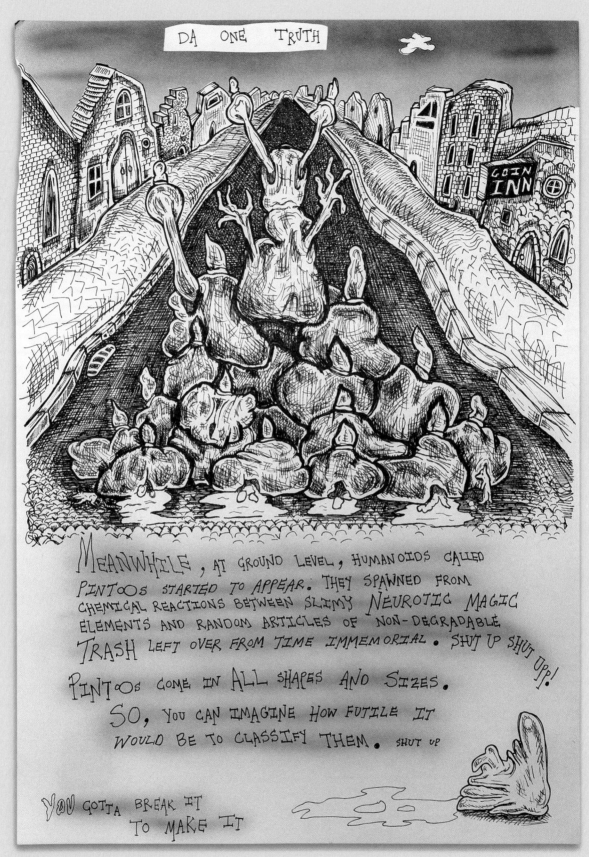

Pintooverse Comic Intro (Page 2), 2023

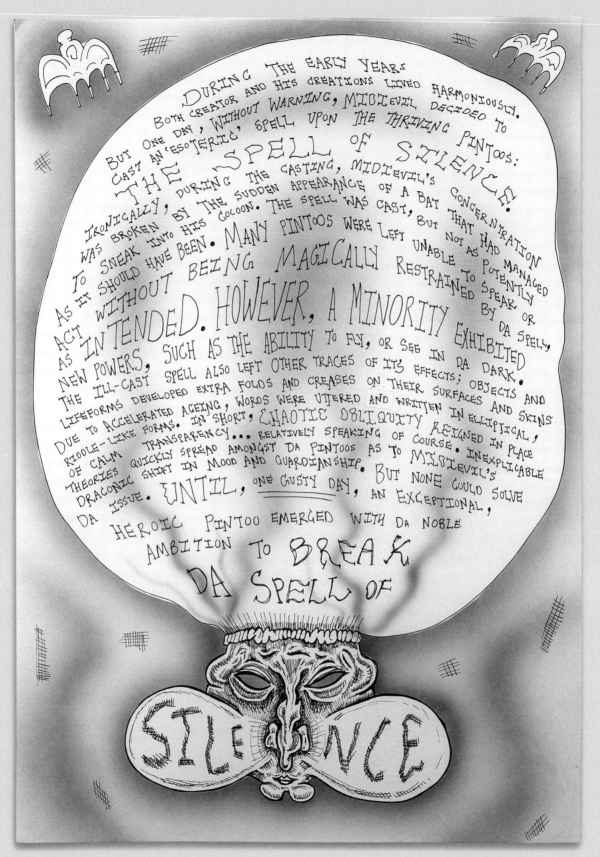

Pintooverse Comic Intro (Page 3), 2023

H: That utopian kind of work only satisfies short-term goals. Without acknowledging the struggle, you do a disservice to yourself and to the audience. You must get under the skin, right to the obscene underbelly of whatever you're interested in, to do any kind of justice to the work. And when you return you must acknowledge the keloids that remain. This is true for any type of practice. For me personally the struggle involves doing justice to both Sikh history and high fantasy. So, I've decided to build a Sikh-inspired Sword and Sorcery universe. This will involve learning more about Sikhism as I continue to immerse myself in dark, fantastical fiction.

D. It is really exciting to think of your work as a "Sikh-inspired Sword and Sorcery universe"! There's a through-line, too, to these recurring depictions of Baba Deep Singh and the Sikh sepoys in your earlier work.

H. Well, the associations conjured in Sword and Sorcery universes align, in my head, with the lore of the Khalsa Sikhs, who dominate media representations of Sikhism – medieval weapons, chivalry and the supernatural. There are various sects of non-Khalsa Sikhs too, which I am also learning about. Yes, I've been working on a motif of a headless Sikh horseman. The motif is a conflation of Ranjit Singh, the first leader of the Sikh empire, and the warrior saint Baba Deep Singh, whose decapitated body, legend has it, continued to fight the Afghan army during the 1757 Battle of Amritsar. Images of auto-decapitation and supernaturally displaced heads are open to multiple interpretations. Considering the context of the Khalsa Sikhs, I am encouraging readings of headlessness within Sikh imagery, less for their heroic connotations and more for their capacity to represent an openness to inexplicable or beheaded forms of consciousness. Essentially, it's about losing one's head(s), becoming headless and more egalitarian in spirit, which I believe is a core tenet of Sikhism.

D. Can you talk a little bit about the difference between an art practice framed as worldbuilding and a practice that isn't framed as worldbuilding?

H. I don't think there's much difference because worlds grow irrespective of how they are framed by their authors. Such growth occurs in fandom, for example. In the context of my practice the difference is more explicit because I have named the world and decided to stay in it, after years of implicit worldbuilding. Perhaps we could make a distinction between active worldbuilding and passive worldbuilding?

D. Hmm, I dunno. I understand worldbuilding as a very active, conscious process of constructing a fictional world. I mean, it's a verb!

H. True. I suppose before this, I never felt truly committed to staying within the small nebulous worlds I made. I never made them easy for others to get into or made any attempt to structure or market them in ways that popular fantasy worlds are. To aid this more active worldbuilding I have been looking at fantasy role-play systems like Dungeons & Dragons (D&D) and *Warhammer*. This has given me a sense of how worlds are described and systematised, and how much lore is out there for a player to participate in gaming communities generally. My intention is for the

"You must get under the skin, right to the obscene underbelly of whatever you're interested in, to do any kind of justice to the work. And when you return you must acknowledge the keloids that remain. This is true for any type of practice. For me personally the struggle involves doing justice to both Sikh history and high fantasy"

Pintooverse to sort of feel on a par with such franchises, in terms of lore, so that aspects of it could inspire Dungeon Masters in their worldbuilding. In my head, I'm constantly devising characters of different classes that have certain traits. These traits could be kind of satirical, for example, or they could be dark. Ultimately, they all connect, you know, to aspects of reality.

D. So for the non-role-play gamers (RPG-ers) out there, can you clarify what you mean by a character class?

H. Sure. In D&D players choose characters categorised according to the type of abilities they have. For example, Wizards are proficient in casting spells and Rangers are proficient in shooting arrows. And these actions have effects upon the creatures who are targeted, usually restricting them in some capacity. The way the characters are categorised in terms of their abilities gives the world a structure akin to a class-based society, particularly if the game world makes it difficult for the characters to drastically change the proficiencies they're "born" with. It tends to be more efficient to keep improving what you start out with. Playing D&D inspired me to consider what a character class or trait could be in the Pintooverse.

D. This is a good example of the shift towards the worldbuilding frame in your practice; the fact you are defining character classes, like in a game system. Also, I assume there would be some play with that other, more common sense of the word "class"? Outside of a gaming context, characters having different "classes" would read as socio economic class, right? And I think one of the satirical edges of your work is sharpened around class and status.

H. Yeah. I think as a worldbuilder you can allow for mobility and interdependence between character classes. Even though it is fantasy driven, there are ways to make it more inclusive or critical. Rules don't have to be so rigid.

D. I mean that when you are adopting the gaming-specific usage of words like "race" and "class", in a non-gaming context, like contemporary art, there's a lot of opportunity for double meanings and associative play. On one level it could just be showing that this world is inclusive, but then there's also an opportunity for commentary about "race" and "class" in different ways.[2]

H. Yes. I am applying this idea in my work. Parts of the Pintooverse are chaotic and frenzied, the result of deliberate over-mixing; both ideas and media formats. It's like I am conveying the cost of attempting to build impossible bridges, like between two colours on opposite sides of the colour wheel. This over-mixing results in the production of a noxious substance that is sometimes colour-coded as brown [laughs] in the Pintooverse, and this affects mutations among characters, giving them various abilities. And it's all to do with like, you know, overcoming barriers, or more simply, taking shit.

D. But yeah, I mean, isn't it sort of a metaphor for art-making? The brown substance that confers these abilities? That's how I would read that. It's a power.

H. Also, the colour-coding/matching, or lack thereof, allows me to embrace being colour-blind more openly. At school I was told I couldn't pursue a career as a visual artist when I first took the Ishihara test. But I liked drawing, so I stuck with it. I am hopeless at mixing colours. That's probably why I have developed a more mixed-media approach, as opposed to, say, making traditional paintings. This is my way of defining what brownness is, a metaphor for going beyond black-and-white politics. Being grey, but from a colour-blind perspective.

D. Sure, but is that an issue? I mean, you know, no one is asking, "Why aren't you making traditional paintings?" Or are they?

H. No, except my shadow self [laughs], but I do consider materiality part of the worldbuilding process. One of the strategies

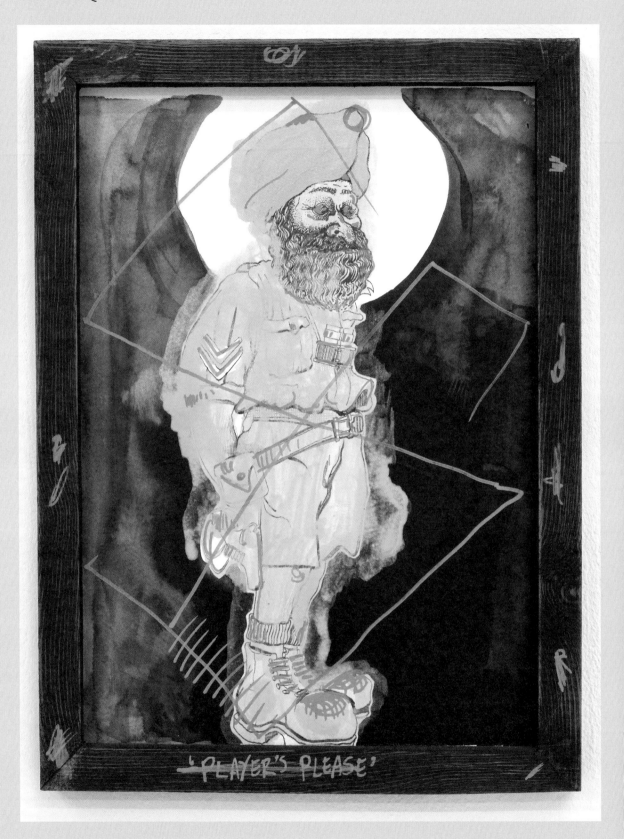

British Sikh Soldier, 2012

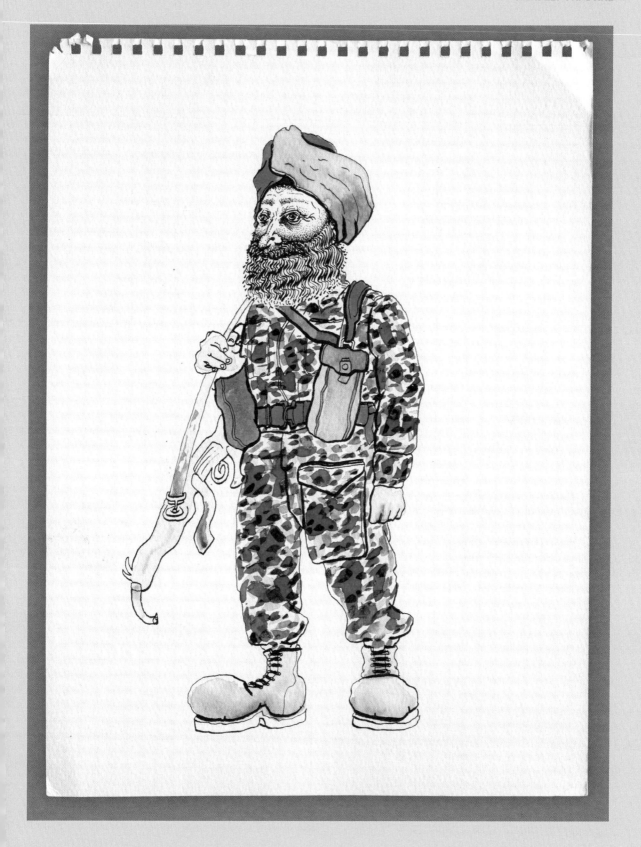

British Sikh Soldier (Four Lions Requiem 2), 2012

I tried out was for some of the characters in the Pintooverse to grow second, balloon-like heads enabling them to fly because they consume and channel the *brown* air around them, and one of the tools I was using to construct the Pintooverse was the airbrush. It felt appropriate because the airbrush is a tool that channels the *air* around me. Also, obtaining mastery of the airbrush trigger is a slow and rewarding process. The learning curve is similar to learning the controls of video games designed to be played with light guns, such as *The House of the Dead* series. Having to reorient your sense of hand-eye coordination is integral to creating a sense of immersion in video game worlds. The airbrush helps me get *into* the Pintooverse.

D. Yeah. The concepts "of" the world are informing the tools you're using to render it.

H. These loops between reality and fantasy bolster the worldbuilding process. They also allow me to be more playful with autobiographical material because I'm drawing attention to my own hand, or lack thereof, self-consciously, in the creation of the Pintooverse. The way the media is applied is affected by the worldbuilding. It is as if I'm a character who has been conditioned by an element in the world, to demonstrate reflexivity and complicity as its creator. I am very loosely prescribing rules within the world so that certain elements of it are rendered in specific media. But the rules are ultimately there to be contested and developed in the narrative. That's what keeps the worldbuilding going.

D. So, yeah, by saying your practice – this world – has rules, and a lore, is that a way for you to circumvent the conventional gallery-wall-text interpretation as something that kind of explains or validates the work? In a worldbuilding context, you wouldn't necessarily have that.

H Yeah. I think it works like that. I also hope the lore is less alienating to encounter than conventional gallery texts.

D. So, aside from worldbuilding as, I guess, like a structure or a kind of organising principle, let's talk about the influence of fantasy more generally, which has more clearly emerged in your work in the last, I don't know what, like few years or something? Could you pinpoint where it's come from? Does it feel like a new thing to you?

H. I think this influence has always been there but it's remained dormant until recently. Coming back to Sikh history, I always thought my earlier drawings of Sikh sepoys looked like gnomes. They're based on miniature war simulation figurines I found on eBay. I wasn't into tabletop war games at the time, as I grew up playing video games. But it was striking to see the sepoys being represented in gaming communities so directly. To what ends I'll never know. I was and still am conflicted about media representations of Sikh sepoys because they run the risk of glorifying or sentimentalising the British military, which I am not interested in doing. But I do care about doing justice to Sikh history. I guess that's why war simulation can be healthy, to circumvent real conflict or sublimate the violent instincts among us. The same could be said for fantasy. I have exaggerated these miniature figurines of Sikh sepoys in various ways in my drawings. I applied a sort of subjective commentary over them, about masculinity. Their guns are small and flaccid. They're like clownish deserters. It's as if I've added various exaggerations to something

"At school I was told I couldn't pursue a career as a visual artist ... but I liked drawing, so I stuck with it. This is my way of defining what brownness is, a metaphor for going beyond black- and-white politics"

that should otherwise be neutral. It felt like subverting a war monument that didn't exist at the time. Remarkably, the recently installed Sikh sepoy monument in Smethwick, Birmingham, was vandalised shortly after it was revealed, reportedly by dissenting Sikhs.

D. Wow. Okay, so here's another loose jumble of connections in relation to fantasy. I mean, your drawings, I think, were probably the first representation of, like, British Sikh soldiers in media, really, that I'd come across, which is telling. Like if we think about Tolkien and *The Lord of the Rings* as First World War allegory. And obviously, one of fantasy's historical problems has been its lack of representation, right? And then we look at that recent idiocy [laughs] in the "fan" response around casting in that new *Lord of the Rings* show.[3] I don't know. Yeah, there's a connection there?

H. Ha, that fan response says a lot! Especially in terms of the connection between fantasy and reality. It reminds me of the RaceFail '09 incident, an online blogging debate where fantasy fans of colour expressed their frustrations and anger with stereotypical representations of characters of colour by white authors. These expressions received a lot of negative responses.[4] Even just having characters wearing turbans in an art practice is a big deal. The turban is a distinct marker, across my work, in fantasy and in the real world. At the end of the first Harry Potter film the Dark Lord is revealed under Quirinus Quirrell's turban [laughs]. The *Only Fools and Horses* episode "Modern Men" revolves around Del Boy's invention of a turban for Sikh motorcyclists. Both examples are dodgy in what they imply: the turban as something to be tamed. The turban is where evil lurks, for example, or it's shoehorned into a plot to fuel canned laughter. Sepoys refused to wear helmets in the world wars in favour of their turbans. The turban is a complex cultural marker, connoting both pride and humiliation to this day. For Sikhs it can literally feel like a

burden on the head. Perhaps I was running the risk of causing offence in my earlier, non-fantastical work too?

D. I guess the kind of clichéd charge, if you like, against fantasy is that it's escapism. And at its worst or least consequential, like sure, maybe that's what it is? But the escapism thing sets up such a crude distinction. Jeff Vance Martin and Gretchen Sneegas talk about how fantasy is rooted in the real world and real people's experiences, both people that are kind of involved in this creation or conjuration of fantasy worlds, but also those who, like, participate in it:

> *The production, circulation, and consumption of imagined worlds does not occur in a social vacuum …*
>
> *Storyworlds have broader social effects via the dialectical interplay between imagined and lived worlds, thus highlighting the material and political stakes of critical intervention. Speculative worlds have become venues for social struggle and debate as diverse social groups wage battles over questions of representation in media (and, by extension, civil society), or the perpetuation of problematic tropes.[5]*

H. I agree with this. My approach has always been reflexive, to make work grounded by some tangible aspect of reality. Invariably though, I will exaggerate and distort real memories. I am human after all. And these exaggerations and distortions are to be nurtured by the worldbuilder in an appropriate and tasteful way. Identifying and contributing to a specific genre can serve as a guide. When immersed in fantasy, my sense of reality is constantly being tested, and when making fantasy, it makes sense for me to make it pivot around elements of reality. So it's not totally escapist.

D. You mention offensiveness. Could you maybe give an example?

H Reflecting on Sikhism, I see it more as a kind of personal space in which you can,

Respect my BAME (name change), 2015

Mother India, 2015

like, mediate between multiple beliefs. When I drew the Sikh sepoys I was kind of testing whether they would be inferred by my art peers as being made in reference to Islamophobia. That's happened quite a lot. People in the UK assume that I am Muslim, and I am making work about that. And I guess the work is linked to that, but from a non-Muslim experience, and directed more at those who homogenise brown subjectivities.

D. So has the tone of your work changed? Is that something that you have had to consider as your profile has risen?

H. Yeah, it's more other worldly. But all art should allow for honesty and criticality. Bringing a radical energy into the work shouldn't be a problem. The angst in my older work laid the foundation for the Pintooverse. But that angst didn't really go away. It mutated into something else. That's what fantasy does. I believe the fantastical turn helps me explore reality in much greater depth because I am freer from the burden of representation. Obliquity is key. I feel more confident about making Sikh art as a result.

D. Are you going soft in your old age?

H. [laughs] Not really. Well, the airbrush makes softer lines [laughs]. Staying in the Pintooverse is harder because it's a longer form. It's just getting deeper.

D. Yeah. And I suppose by holding a *world*, an ongoing thing, like all these ongoing narratives and characters, it means that it can't really be flippant? There's a great degree of care and responsibility that goes into it.

H. Absolutely, of course. Taking responsibility for a world is more transgressive than being responsive or reactive to impulsive curatorial conceits or topical events. Worldbuilding is also helping me refine the rapping sphere of my practice. I can assume multiple personas in the world. Presenting rap within an art context has been a rewarding experience, don't get me wrong. The gallery context is just different, right?

D. Yeah. Could you briefly outline the "rapping sphere" of your practice?

H. It's simply the facet of my practice where I rap. Rap usually features in the scores of my videos. Written lyrics also appear in drawings and paintings. My current rap name is MIDIevil.

D. Do you think there's a danger of it having to become didactic, or even like sort of expository? Since rap's such a linguistic art form and allows for all this slipperiness and playfulness and ambiguity with words and meaning, do you think this is kind of tamed somehow by the gallery context?

H. I think so. Also, unfortunately, a lot more attention is given to visual media generally and the recorded voice work often gets lost, I feel.

D. As I see it, there are two main strategies that one could employ to address that. One would be to offer more guidance, like through interpretation, lyric sheets or captions. And then the other strategy is – as you seem to be leaning towards – to parcel it all out, so that the rap is presented as unqualified "music" on, and through, usual music platforms and distribution channels.

H. I've been distributing my rap work recently on YouTube in the form of DIY-style music videos – in addition to presenting it in a gallery. Either way, I won't ever stop writing lyrics or showing them in exhibitions or artworks. The process is important. And I suppose as you're rapping, you question what a gallery context can be. Even just working across different media raises questions. Each medium possesses unique features and cultural connotations that I want to explore. My media choices and application methods are largely driven by my class consciousness. The challenge is to convey both tonal consistency and political integrity among the various mediums used.

D. What sorts of associations and effects do you think rapping generates in your practice?

H. For me, the compulsion to rap or speak in rhyme is connected to oral storytelling. You can distil complex associations into catchy lyrics, or engaging wordplay that people can keep in their heads. My lyrics often refer to other works in my practice, so it allows for cross-referencing and auto-interpretation. I can kind of assume the perspective of a critic and steer interpretation. There's a braggadocious element to my approach, which is inherent to the genre of rap. Initially, there was kind of a jokey, self-deprecating element to my rap. But you know, more recently it's become more serious. I'm trying to be good at it. I was recently invited to be in an exhibition about hip-hop in contemporary art and I was asked to write a short essay for the exhibition catalogue about what hip-hop meant to me. Here's an excerpt:

> *Rap can be many things. For me it is confessional, confrontational, nuanced, playful, and even educational. Furthermore, writing rap lyrics gives me the opportunity to compensate metaphorically for the limited communication I can have with my mother and the disconnectedness I feel with my broader parent culture. I get to explore the copiousness of verbal and written English in ways that I cannot at home, via means of ventriloquistic confession and exaggeration.*

D. Do you feel like there's a persona, or personas, like a kind of rap version of yourself that's emerged and is distinct?

H. I think there is in my head, like MIDIevil is an extension of me. And I think it's evident in existing work. My current lyrics are framed within the Pintooverse. So, the compulsion to rap is like a symptom of the forces operating in the world, effecting both the characters and me. MIDIevil unwittingly emerged from the Pintooverse, before I even named it!

> "Your drawings, I think, were probably the first representation of, like, British Sikh soldiers in media, really, that I'd come across, which is telling. Like if we think about Tolkien and *The Lord of the Rings* as First World War allegory"

D. We were always in the Pintooverse. Aren't you retconning a bit though? [laughs]

H. The Pintooverse is where I came from. That's a good answer for when people ask where I *actually* come from [laughs].

D. In terms of locating the rap "in" the world, would you see a project like Drexciya as a sort of precedent maybe? Drexciya made this banging electro-techno, totally influential on its own terms, but the music is just one part of a wider conceptual project based on powerful Afrofuturist mythmaking. So the musical identity is intrinsically connected to the worldbuilding.[6]

H. I mean, Drexciya is a good example, you know. From my understanding the project was like a mythical narrative grounded in history. They created a world undersea and you kind of inhabit that space as you listen to it. Dungeon synth artists create parallel worlds too. Some dungeon synth labels produce and package mini adventure scenarios with dungeon synth tapes. Perhaps this is an attempt to foreground the music as an integral element of the world, rather than being simply background music to play the game. You must buy the music on tape to access the game.

D. I guess it's kind of circular in the case of dungeon synth? That genre comes pretty directly from D&D/RPG culture in the first place, as far as I understand it – by way of black metal.[7] So, which rap artists do you think have been most influential on your music?

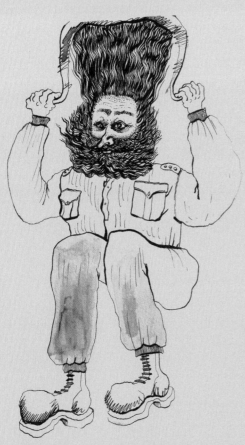

Opposite
British Sikh Soldier, 2012

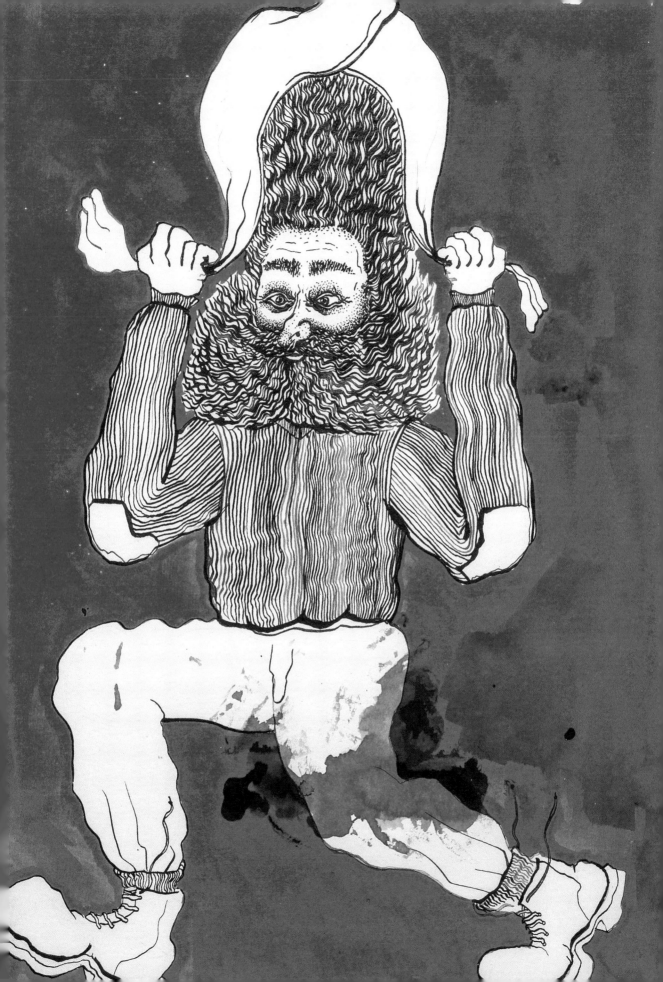

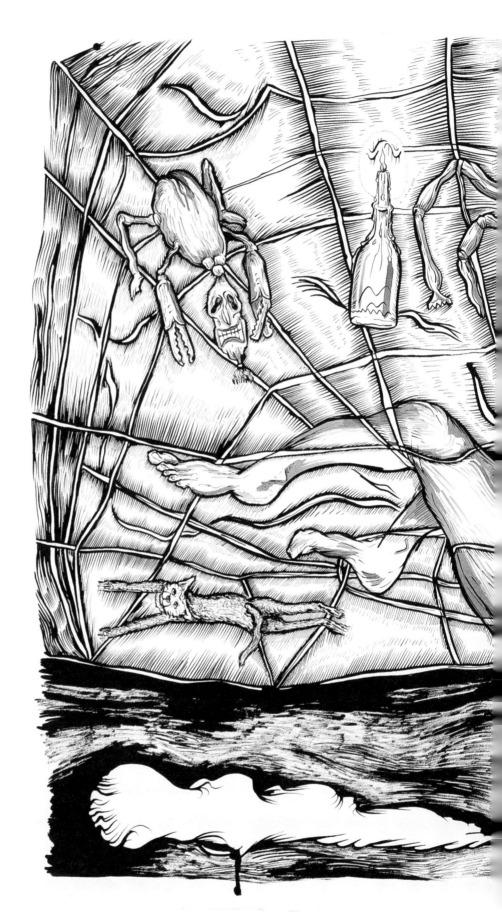

Thugs and Vandals,
Charmed By Gorgoroth XI,
2021

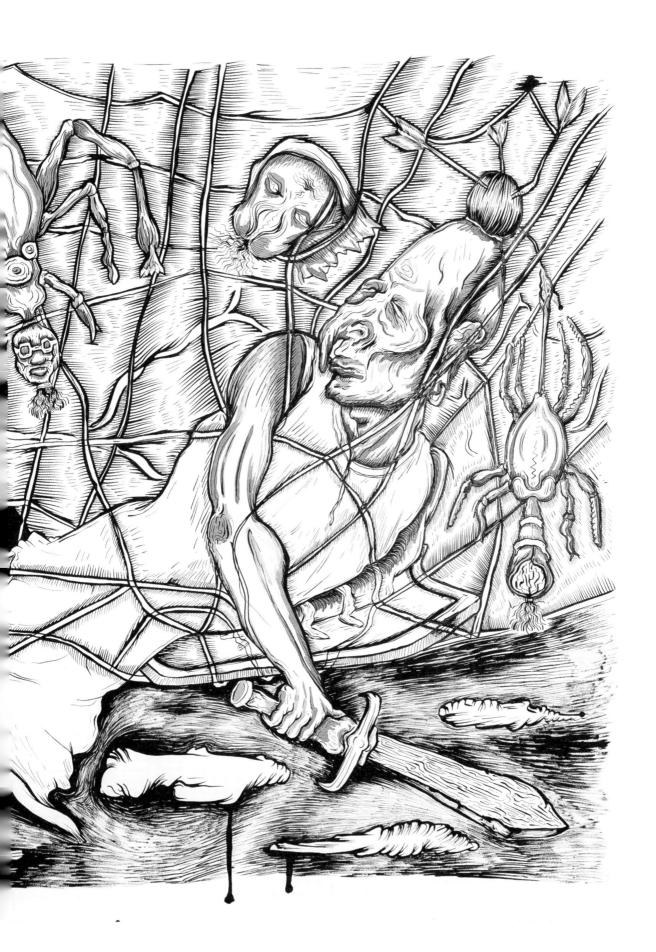

H. Lil B maybe, in terms of the last ten years. He represented a different generation and approach not just to the music but also to being an artist generally, in terms of self-definition. He's very independent, and through the music he's resisted being pinned down easily. This appealed to me. He's also funny, grotesque and sort of strange.

D. Earl Sweatshirt tweeted that the three most influential rappers of *his* generation were Chief Keef, SpaceGhostPurrp and Lil B. Which I think is really probably accurate, but probably that's another interview [laughs]. With Lil B, I hear his influence in the surrealism, the artist-invented idioms, the hyper-productivity of rap today. There's an influence there, too, maybe with artists who have inventive, independent ways to kind of package themselves. Someone like Tierra Whack, or Certified Trapper, who also uses music videos in very specific ways.

H. I think in a way, it's like Lil B's embracing this idea of just talking absolute shit, but then also meaning something. Shit-talking is the one of the essences of rap. Things aren't so black and white in the music sometimes. It's quite uncompromising. You have to kind of read between the lines, you know, to appreciate it. And it does get into dark territory. It's honest.

D. Yeah. It's also very, like, kind of imagistic. Surreal metaphors… and there's always a kind of plausible deniability because of the art form, or just the fact that it *is* an art form. I wonder whether this sort of wider cultural under-appreciation of rap music is tied into a limited idea of it as, like, reportage, basically. There's elements of that, of course, but it's not like… I don't know why people would take it all completely literally.

H. It's an intertextual medium for sure. Rappers tend to unpack, you know,

previous generations of rap music, and maybe the problems within it to a degree. And there's a quick turnaround. Things sound old quickly. So, there's a disavowal, but also a kind of slippery reclamation of rap history in the music of newer rappers.

D. It's in dialogue with older sounds and styles. To go back to that tweet, Raider Klan really epitomised that influence, that quotational thing. The Three Six [Mafia], Memphis worship. And then Raider Klan goes on to influence weirder and weirder SoundCloud stuff like Jewelxxet. But I think it's also part of the mainstream texture of rap, too. The dialogue.

H. When I was younger, I listened to a whole range of rap, whatever I could find. I listened to gangster rap, southern stuff, screwed and chopped, horrorcore, backpacker stuff, independent stuff and stuff I don't even know the name of! Yeah, it's really sort of messy and edifying to try to give rap attention. You know, I mean, to understand it on the terms that it's trying to be understood, as complex.

D. Why do you keep changing your rap name?

H. It reflects a desire for not wanting to be fixed, for demonstrating mutability. Also, I'm throwing my voice. It's not instructional. The lyrics *don't* need to be taken so literally! I sort of get into a state of seeing myself objectively and playing around with that. Yeah, like estranging myself from myself, and embodying that estranged subjectivity. I am sure

"Worldbuilding is also helping me refine the rapping sphere of my practice. I can assume multiple personas in the world. Presenting rap within an art context has been a rewarding experience"

there's a connection there to horror and Gothic tropes of split subjectivities, of doppelgangers or of otherworldly possession.

D. Earlier you talked about "confronting ideas of weirdness", and now you raise spectres of horror and the Gothic. I wouldn't say that horror is as pronounced a kind of visual language in your work in comparison to fantasy. But obviously your work's always been potentially menacing, and confrontational. A lot of humour, but also a lot of, like, violence. I suppose that the characters don't often look like they're having a good time, do you know what I mean? And maybe especially in your animations, which show us this animated, or sort of barely animated, *procession* of exaggerated and distorted forms and figures. It's very carnivalesque. A masquerade, existing in some sort of impossible space.

H. Mikhail Bakhtin's book on Rabelais was an influence, particularly the idea of the carnivalesque being like a release of pressure, from a societal perspective.[8] And I guess you can see that carnivalesque function quite clearly in British political cartoons. The British humour I grew up with was full of cringey, self-deprecating innuendoes. Yeah, that weird British sense of humour is tested in the animations. There's maybe an expectation or a desire among viewers to want fluid, longer bits of movement or lip-syncing from characters, something direct and familiar, like cartoons on TV. This is forestalled in my animations. So, you get these short-lived, frustrated moments of life. They're more like gifs, I suppose. And there's multiple address in the voiceovers. The characters' speech is mixed up with the narrators' speech.

D. But I think that, you know, there is an inherent sort of uncanniness in that, like the insufficiency of the render or the bringing-to-life, you know, like a kind of glitch. It's connected to horror, for me anyway.

H. Yeah. And I guess there's a distinction between sociocultural or real horrors in the world and art horror. You know, things that are actually horrific in real life and then things that induce a sense of dread in more contained, safer spaces, for willing audiences to feel some sort of effect or undergo an experience. Also, my characters have been based on identities that are perceived to be threatening in real life. So, the wider cultural context has a part to play in making that distinction. Do you know what I mean?

D. Yeah. And I think that distinction can be useful and necessary to uphold at times, even if only out of sensitivity or propriety or something.

H. More recently I've been looking at South Asian demonic imagery to further my understanding of South Asian Gothic. For me, experiencing such things, like a sense of dread, within literature or film, relates to a spiritual sense of self-discovery, like peering into an abyss. I think it requires a lot of trust in the audience, or like a broader culture to kind of have faith in it. This leads on to another terrifying question [laughs]: are safe spaces, such as art exhibition spaces, becoming too safe?

[Drunk man appears and puts drink on HP/DS table].

Drunk man in Britannia. [to phone] I don't actually know.

H. Yeah, that's the thing. What is scary is the idea that, you know, culture becomes quite sanitised. You can convey the idea of violence being enacted in a narrative, but does the audience identify with the victim or the perpetrator? How do you know?

D. That question of how the audience, the content of the narrative, and the construct of the artwork itself all triangulate is really interesting to me in relation to horror. I think, as a genre, horror really excels at strumming those tripwires and creating

tension around how, what and why we identify [with something]. I have been thinking recently about what we might call a kind of "horror-of-viewing", where the mechanics of how all that tension is generated – that is kind of precisely where the horror's located. And oh, I was going to ask if you thought that, like, the risk for artists working with demonic imagery was that they might actually, you know, unleash a demon [laughs]?

H. Oh, absolutely [laughs]. Yes, undoubtedly. The images follow you everywhere. It's like the idea of apotropaic magic, you know, telling stories of demons keeps them at bay. Like it inoculates you spiritually.

D. And, yeah, I mean, you're just asking for trouble.

Endnotes

1 Kennard, Peter and Hardeep Pandhal, "Hardeep Pandhal interviews Peter Kennard", *Aspex Portsmouth*, July 2021, www.aspex.org.uk/wp-content/uploads/2021/07/Hardeep-Pandhal-and-Peter-Kennard-Interview.pdf, accessed 12 December 2022.

2 On 1 December 2022, shortly after this interview was recorded, Wizards of the Coast announced that they were dropping the term "race" in favour of "species" in future editions of D&D. See "Moving on From 'Race' in One D&D", D&D Beyond, 1 December 2022, www.dndbeyond.com/posts/1393-moving-on-from-race-in-one-d-d?utm_campaign=DDB&utm_source=TWITTER&utm_medium=social&utm_content=8327757538, accessed 5 March 2023.

3 Young, Helen, "The Rings of Power is Suffering a Racist Backlash for Casting Actors of Colour – but Tolkein's Work has Always Attracted White Supremacists", *The Conversation*, 8 September 2022, www.theconversation.com/the-rings-of-power-is-suffering-a-racist-backlash-for-casting-actors-of-colour-but-tolkiens-work-has-always-attracted-white-supremacists-189963.

4 Young, Helen, *Race and Popular Fantasy Literature: Habits of Whiteness*, New York and Abingdon: Routledge, 2016.

5 Martin, Jeff Vance and Gretchen Sneegas, "Critical Worldbuilding: Towards a Geographical Engagement with Imagined Worlds", *Literary Geographies*, vol 6, no 1, 2020, pp 15–23.

6 David, S, "Inside the Stunning Black Mythos of Drexciya and its Afrofuturist '90s techno", *Ars Technica*, 28 February 2021, www.arstechnica.com/gaming/2021/02/inside-the-stunning-black-mythos-of-drexciya-and-its-afrofuturist-90s-techno.

7 Akimov, Ruslan, *Dungeon Synth: The Rebirth of the Legend*, United Kingdom: Cult Never Dies, 2021.

8 Bakhtin, Mikhail, *Rabelais and His World*, Helene Iswolsky trans, Cambridge, MA: MIT Press, 1971.

Opposite
Detail of *Spell Concentration 2*, 2023

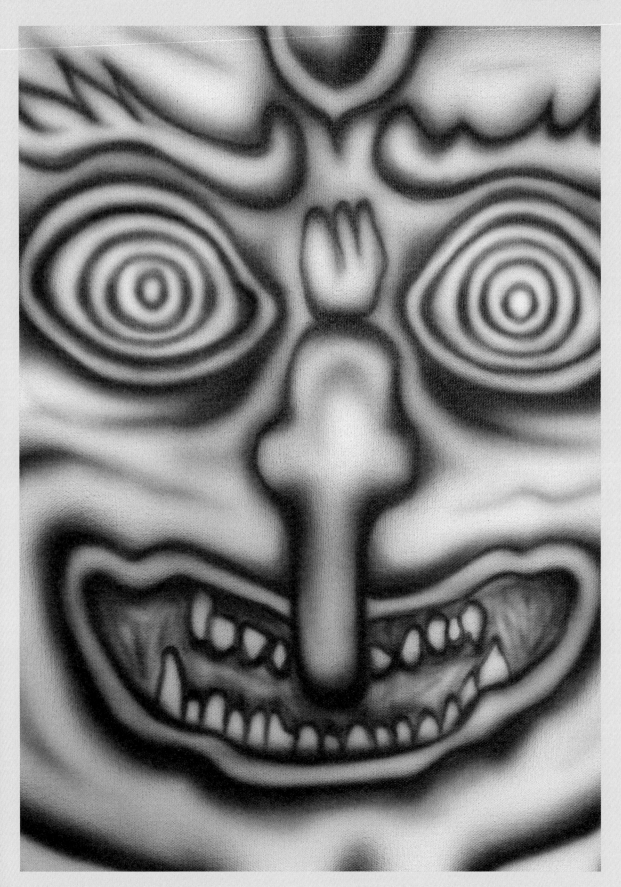

Opposite
A Silence That Speaks Volumes, 2023

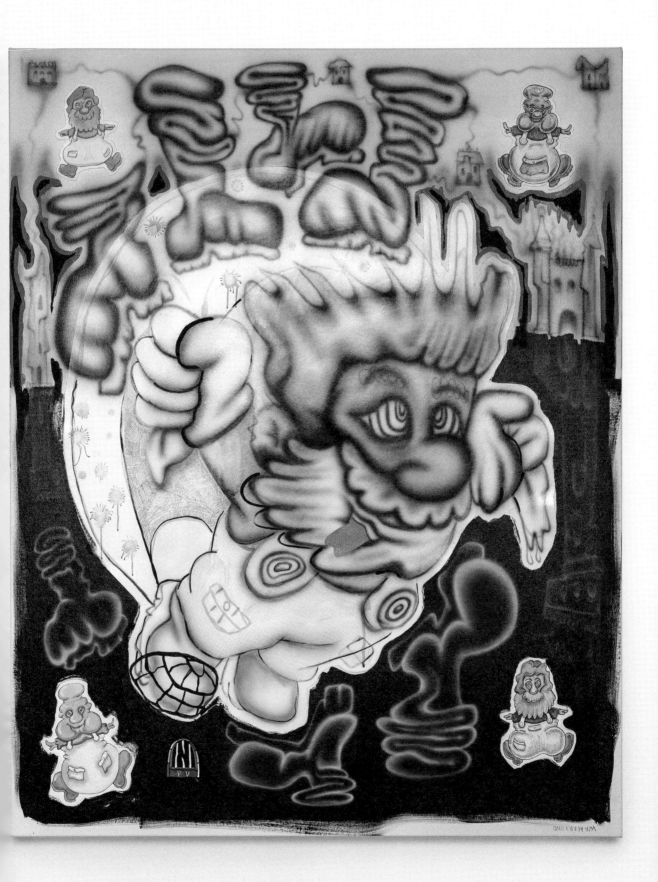

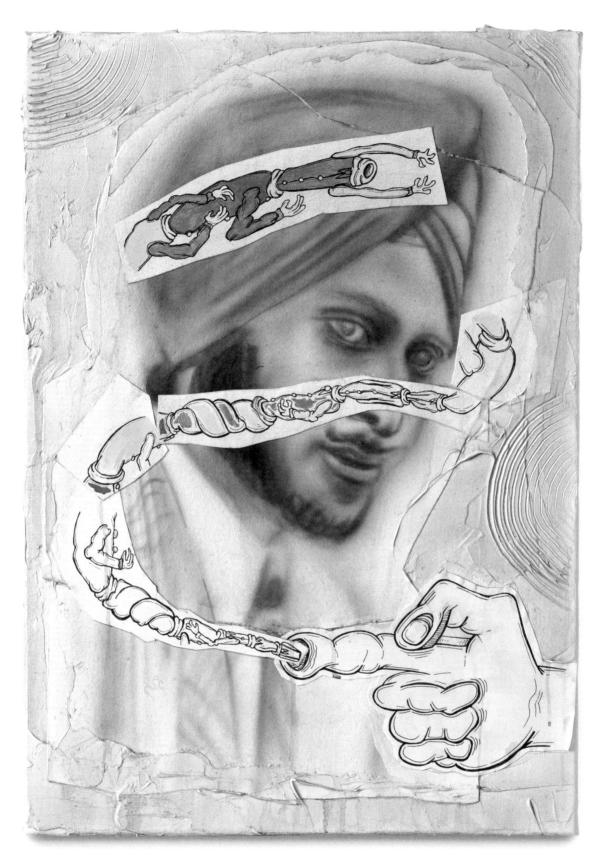

A Familial Romance (diptych), 2023

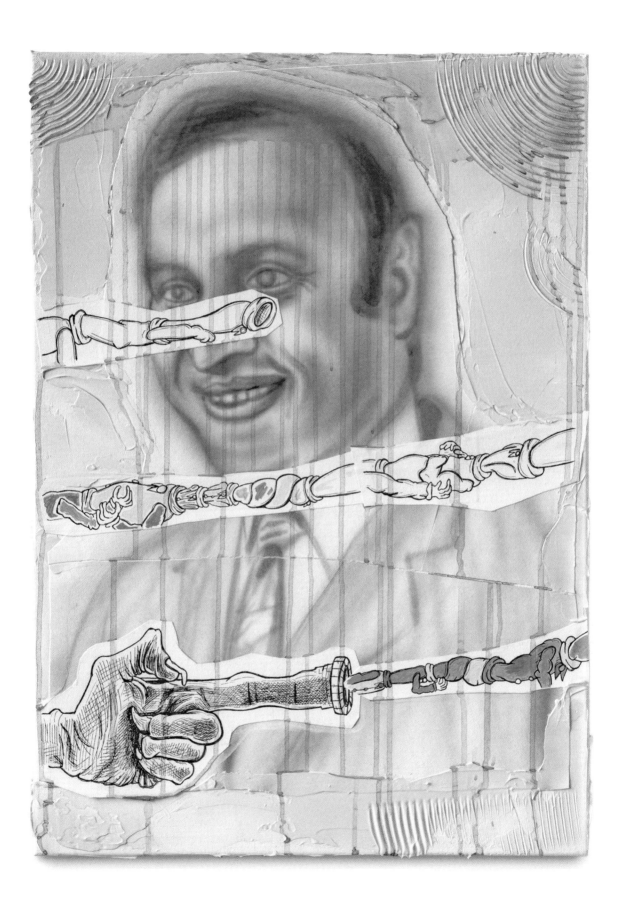

Opposite
Untitled (Bridge of Blah Blah Blah Blah), 2023

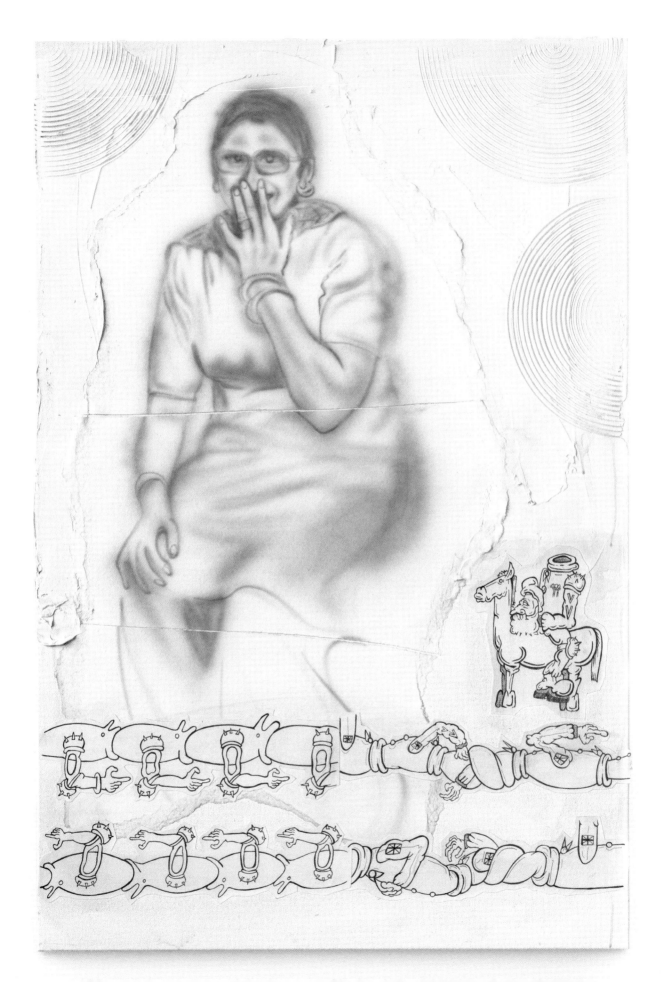

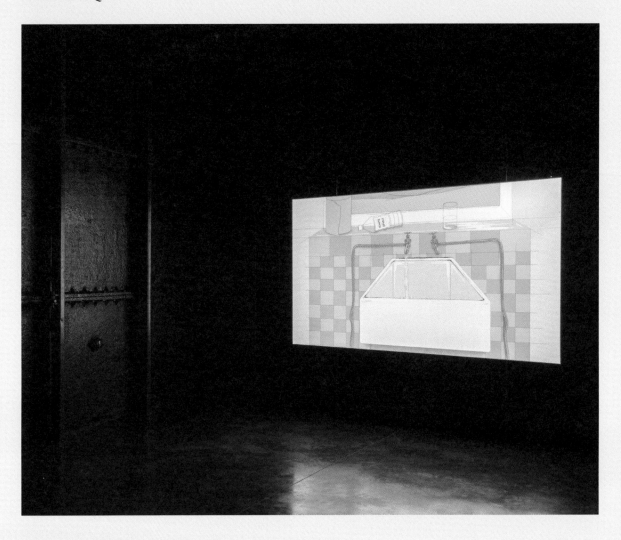

Installation view of *Ensorcelled English* at Goldsmiths CCA, London, 2020

Stills from *Ensorcelled English*, 2020

THE HOBBITS OF WHITENESS, OR, BIRMINGHAM AND BACK AGAIN: ON THE TOUGH BUT FAIR ART OF HARDEEP PANDHAL

BY JAMIE SUTCLIFFE

There are fantasies that make the world clearer, or help people to bear it. There are fantasies that numb us, and dupe us, or capture our imaginations in order to extract from us something which we did not consent to give. Fantasies as cover for the operations of colonialist-capitalist power. There is no conquest possible without first imagining it.[1]

Meghna Jayanth

"Viriconium" is a theory about the power-structures culture is designed to hide; an allegory of language, how it can only fail; the statement of a philosophical (not to say ethological) despair. At the same time, it is an unashamed postmodern fiction of the heart, out of which all the values we yearn for most have been swept precisely so that we will try to put them back again (and, in that attempt, look at them afresh).[2]

M John Harrison

I. WELCOME TO BLIGHT TOWN

Much like a hapless sorcerer's apprentice running amok in sepulchral halls of dark scholarship, the British artist Hardeep Pandhal sets to work a living bestiary of unruly icons, bone-weary tropes and wretched revenants of empire in acts of acerbic cultural disarticulation. Called forth by his trembling pen, pressed into terminal loops as animated gifs, conjured by acts of mix-tape mesmerism or ghoulishly manifested by the phantasmic spray of an airbrush, these entities perform a pantomimic gloss upon hazy-headed presumptions of class, race and the often unquestioned instrumentalisation of heritage.

Shambling among this cartoon carnival of souls we may glimpse the British Muslim boxer Prince Naseem Hamad sparring in a pair of Union Jack-emblazoned Doc Martens boots; Link, the androgynous Aryan elf hero of Nintendo's video game series *The Legend Of Zelda* (1986–present), partaking in a colour-blind casting call; the thespian Ben Kingsley browning up for his role as Mahatma Gandhi in Richard Attenborough's eponymous 1982 biopic; or British Sikh soldiers choreographed into various states of martial readiness or historical subjection. The still-animate severed heads of Sikh martyr Baba Deep Singh or working-class actor Sean Bean might emerge from this rowdy rabble, totemically floating or pathetically impaled upon broadswords, while the oracular fan-art emanations of rappers Lil Wayne or Tupac Shakur are likely to preside over the grotesque festivities, narrating mythic continuities of thuggish lives.

Pandhal's menagerie is summoned from the cankerous mainlands of a well-worn pop-cultural map, its topographies deeply inscribed with cryptic confessional annotations of Indian ink and THC-fortified vape juice. These subjects aren't the rarefied currency of any specialist research but the backlit sprites of YouTube binges and 4K gaming monitors; the exaggerated personages of Wireless Festival and Sword and Sorcery novels; the chimeric populace of a transcultural phantasmagoria. This is Pandhal's Blight Town, where cultural markers are smudged, blurred and degraded through acts of artistic reconfiguration – where meaning marks, taints or carries like curses.

II. THE FOG ON BULL STREET

Pandhal hails from the back streets of Cape Hill, Birmingham, a major city in the West Midlands of the United Kingdom notable for its smog-choked arterial motorways; its industrial pedigree (James Watt and Matthew Boulton would develop and manufacture the first steam engines at Smethwick on the city's outskirts in the late 18th century); the mythically inflected heavy metal of Black Sabbath (whose distinctive sound many have attributed to the loss of two of guitarist Tony Iommi's fingertips in a sheet metal factory accident); and its long-established South Asian population.

Like any self-respecting working-class artist negotiating the rancid character generator of the neoliberal arts sector, Pandhal has played fast and loose with his own origin story. Indeed, he seems to have carefully constructed himself as a cloaked envoy, or heteronymous assailant, to evade the interpretative redundancies or institutional

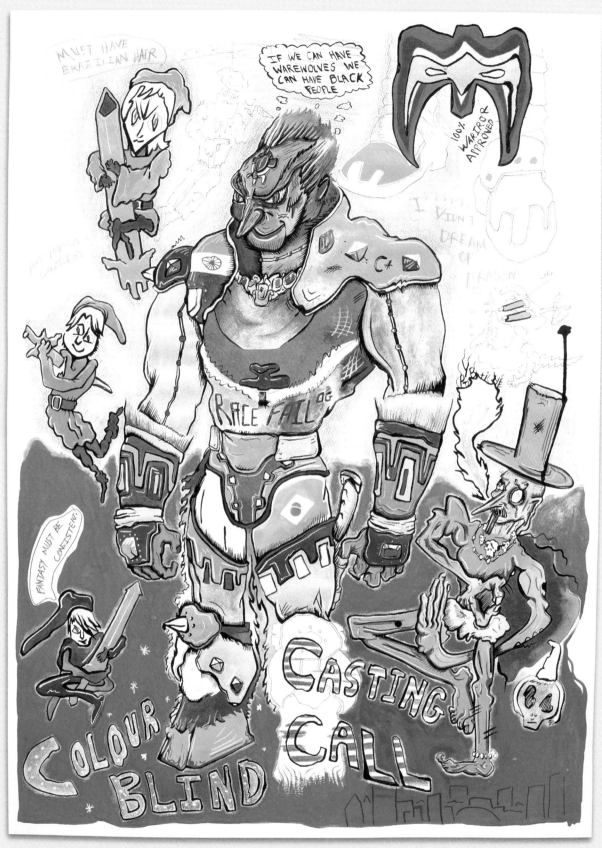

I Didn't Dream of Dragons, 2018

apprehensions of his identity as simply and reductively "British Asian" or "Sikh". In the exhibitions and individual works that have characterised his practice for the past several years, we rarely encounter Pandhal as an individual, but instead through an uncanny coterie of impish proxies. Where a different type of artist – Cameron Jamie or Cindy Sherman for example – might employ masks to obfuscate and problematise the notion of identity and its attendant feedback loops of projection and actualisation, Pandhal opts for the auto-poetic licence of the rap moniker as a vector of half-truths and manipulated fantasies, autobiographical admissions and fictional evasions. Are these the works and words of "Hardeep The Wicker Man"? "Pakivelli"? "Sepoy Mario"? Or, as both the artist's occasional instagram moniker and a significant comics work produced in 2021 imply, the retributions of a "Tolkien Artist"?

Greater than a bastardised lyrical allusion to the deceitful institutional practice of tokenism, this name-drop, common in Pandhal's work, positions the British writer JRR Tolkien prominently in the artist's burgeoning imaginary. Author of the modern fantasy Ur-texts *The Hobbit*, 1937, and *The Lord of the Rings,* 1954, Tolkien's fanciful worlds have lent Pandhal a model of imaginal intensity that might be said to undergird the development of his own Sikh-inspired Bildungsroman. But they also provide a visual and thematic repertoire of racialised conflict, animated by a deeply colonial impulse – where light-skinned protagonists appear to be locked in eternal opposition to a crudely defined "darkness" from the East – that continues to provide structural armature to the endlessly popular contemporary fantasy genre.

Born to a settler family in colonial South Africa in 1892, the young Tolkien would develop a lasting fondness for Birmingham following his family's relocation to the village of Sarehole on the city's outskirts. Sarehole's distinctive corn-grinding mill and the surrounding sylvan landscapes of Moseley Bog and the Clent Hills would supply the homely inspiration for the moss-cloaked glades, mushroom-sprouting

"Tolkien's fanciful worlds have lent Pandhal a model of imaginal intensity that might be said to undergird the development of his own Sikh-inspired Bildungsroman. But they also provide a visual and thematic repertoire of racialised conflict, animated by a deeply colonial impulse"

woodlands, trampled tracks and warming taverns of The Shire (the verdant green heartlands of Tolkien's fictional universe), while the eldritch-industrial Victorian splendour of Edgbaston Waterworks, Perrott's Folly and the University Clock Tower would furnish him with grimly resonant symbols of a magical-intellectual arrogance.

The industrial envelopment of Tolkien's cherished Black Country is strikingly allegorised in his literary work. From the broiling furnaces of Mordor, through the biomechanical production of a dark-skinned underclass in the Orc pits of Orthanc, to the arcane otherness emanating from the libraries of Barad-Dûr, Tolkien imagined these noxious topographical correlates in order to symbolise the technological and migratory velocities of an anxiously anticipated modernity, a historical trajectory that he feared might come to swarm his beloved rural sanctuary.

Pandhal's contemporary Birmingham perhaps embodies the scourging of a hallowed ground in the Tolkienesque imaginary, a chrome and concrete accretion of commerce and cross-cultural drift whose divergent intensities might threaten any sense of parochial conservatism with its kaleidoscopic alterity: the carnivalesque pomp of its huge sporting arenas and exhibition halls; the geek tat of high-street chain Forbidden Planet; the wondrous junk sales of electronic gaming paraphernalia at Bull Street's Computer Exchange (CEX); the subdued, soot-blackened platforms of New

Street Station with their promised connections to the urban art enclaves of Glasgow, Liverpool and London; or the veritable Jabba's Palace of any JD Wetherspoon or Caffè Nero. This is the fecund soil of a warped British modernity from which Pandhal's own mythos flourishes.

III. THE HOBBITS OF WHITENESS

In her sobering 2016 book *Race and Popular Fantasy Literature: Habits of Whiteness*, the theorist Helen Young explores the uncomfortable centrality of race to the contemporary fantasy genre, delineating its persistent presence and often retrograde articulations through a medium commonly supposed to be defined by its fabulatory ambition and lyrical boundlessness. "Fantasy formed habits of Whiteness early in the life of the genre-culture, and is, in the early decades of the twenty-first century, struggling to break them," she writes. "Those habits take multiple forms: some are to do with the bodies which have traditionally dominated its spaces – in both the real and imagined worlds; some with the voices that are most audible; and some with the kinds of sources which inspire imagined worlds, and the ways that they are used."[3]

Young reflects on the representational and ideological impasses of fantasy literature – from significant franchises such as George RR Martin's infamous *A Song of Fire and Ice* series (1996–present), to the RaceFail '09 controversy surrounding the rightly heated fallout of an essay on "writing the other" by genre stalwart Elizabeth Bear – before drawing upon the work of Sara Ahmed to suggest that fantasy as a mode of cultural production might constitute its own "habit worlds" in which behaviours of repetition shape the possibilities and opportunities of the bodies they represent, envelop and produce. It is a general truth of critical race studies that whiteness remains invisible to itself, but this obfuscation is concentrated peculiarly in the endless refractions of fantasy's own alluring, shimmering edifice... a fortification guarded from unwanted intrusions by toxic fandoms or, more insidiously, inhabited as an "Anglo-Saxon" quasi-mythology by the reactionary right.

Contemporary art has, for the most part, swerved on popular fantasy, embracing instead the positivist horizons of a cerebral futurism that is often neatly codified in conveniently solutionist terms. More interesting perhaps, are the dissident tributaries described by Ana Teixeira Pinto in her 2019 essay "Alien Nations" as "chronopolitical acts". These are divergent strains of science fiction that seek a reclamation of futurity for Afro, Sino and Gulf communities, fabulative practices that work to restore equitable futures to communities excluded from the predominantly white patriarchal imaginaries of classic science fiction.

Fantasy, however, is a comparatively conservative genre, often rooted in folkloric traditions and evocations of rural simplicity. For the cultural critic Fredric Jameson, the amnesiac medieval landscape of fantasy, with its "dungeons and magicians, its dragons and hand to hand combat", fails to embrace the historical mode of consciousness that makes science fiction so pressingly vital to a contested present. Science fiction's momentum is generated by its rapid departures from a recognisable modernity, whereas fantasy commonly wallows in antediluvian complacencies, caked in the thick mud and mire of romance and delusion. Perhaps it is the fundamental "shittiness" of fantasy that appeals to Pandhal as a kind of grim, dark index of a specifically British contemporaneity, an era still enraptured – despite its market-oriented, tech-appended optimism – with the sour pageantry of imperial hubris. Given the genre's supposed structural limitations then, Pandhal's ongoing embrace of the high fantasy vernacular is curious to say the least. He's certainly not pamphleteering for

> "Pandhal's contemporary Birmingham perhaps embodies the scourging of a hallowed ground in the Tolkienesque imaginary, a chrome and concrete accretion of commerce and cross-cultural drift"

a diversification of representation, alongside genre heavyweights Nalo Hopkinson or NK Jemisin, although he'd undoubtedly see these authors as allies. Neither is he scoping for a book contract as an ambitious scribe; his work refutes the logic of the bourgeois novel in favour of the illogic of the fragment. His drawings, short animations, mix-tapes and music videos rarely overlap with the literary world of genre publishing, and yet they remain *deeply* literary in lyrical ambition and allusive power, coursing with arcane and often sardonic (yet affectionate) allusions to the work of fantasy hacks CL Moore, Fritz Leiber, Jack Vance or, perhaps most importantly, the Mumbai-born gay S&M enthusiast and chronicler of Arthurian boyhoods, TH White.

So what rhetorical weapons might Pandhal be sourcing from fantasy's trapped chests? What potent analogies of monstrosity might he be teasing from its most withered bestiaries? If we were to treat his recent projects as abstruse manuscripts, subjecting them to a kind of poxed and frenzied illumination, what registers of critical fictioning might we find ensconced among their dense palimpsest of dark fantasy tropes?

IV. FROM THE GUTTERS OF LANKHMAR

The sinuous line of his distinctive drawings is integral to Pandhal's work. Often unfolding synchronously with caustic annotations, these image-text hybrids populate a kind of "exploded comic", functioning as both single-page treatises and interlinked narrative. Stylistically reminiscent of the juvenile, jittering facetiousness of *Real Deal* (1989–2001), the smut-laden, libidinally untethered comics of American cartoonists Lawrence "Raw Dawg" Hubbard and RD Bone, Pandhal's anti-comics function as a kind of "brownsploitation" ephemera, an undergrowth of literature rendering both graphical bodies and graphic sentiments prone to salacious and over-interested liberal interpretations and projections. By rejecting the medium's central structuring principle – that clean white authenticator of content known simply as "the gutter" – in favour of images that float upon the page, Pandhal's comics somehow become "all gutter", a graphical and notational shambles where sentiments of disaffection coagulate like a viscous run-off.

In *Retribution of a Tolkien Artist*, 2021, a six-part narrative work produced on the occasion of the exhibition "Beano: The Art of Breaking the Rules" at Somerset House, London, Pandhal recasts Leeds City Art Gallery as a temple of menace and cultural exclusivity. Atop its Cyclopean stone steps the building's front door is represented as a portentous yawning portal, a hazardous gateway into a netherworld of skewed values. While the comic draws heavily from the parodic tonalities of the legendary fantasy strip *The Fineous Treasury*, a good-natured send-up of gaming culture that was reproduced in *Dragon*, a role-playing games magazine between 1975 and 2007, the image is perhaps somewhat more immediately reminiscent of David A Trampier's *Great Green Devil*, an iconic artwork used to illustrate a trapped threshold within Dungeons & Dragons' most notoriously punishing module, *Tomb of Horrors* (1978). This "Devil" took the form of a sculptural relief that would tempt adventurers with its hidden depths but forever annihilate anyone bold enough to pass through it. Pandhal's doorway is similarly screened by an ominous distortion, a magical film or membrane that dramatises the strange displacements of cultural hierarchies. "What kinds of annihilation, erasure or terminal complicity await this gallery's visitors?" the Dungeon Master in your head may ask.

The comic recounts Pandhal's real-life banishment from Leeds City Art Gallery during the run of Mark Wallinger's curated exhibition "The Russian Linesman", an exhibition that purportedly explored "cross-cultural boundaries and notions of liminality". The show included footage of the highly charged Wagah–Attari border ceremony between Pakistan and India, ripped from YouTube and displayed alongside curious artefacts and artworks such as photographic representations of the death masks of visionary poets or stereoscopic images of Third Reich monuments. While the circumstances of Pandhal's barring aren't fully sketched into

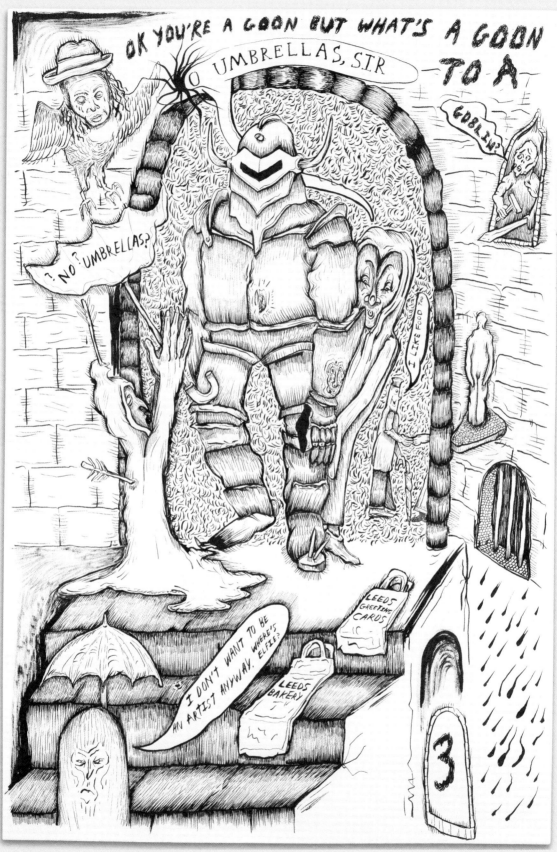

Retribution of a Tolkien Artist (3), 2021

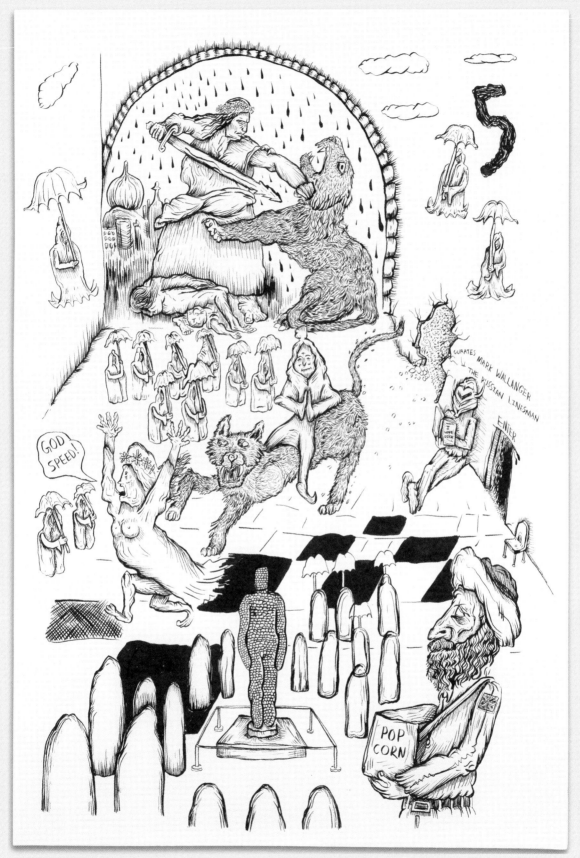

Retribution of a Tolkien Artist (5), 2021

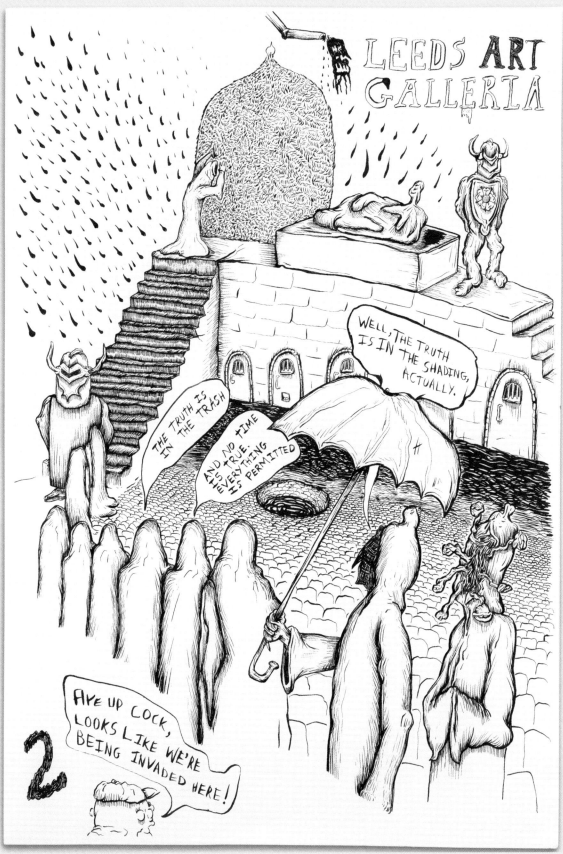

Retribution of a Tolkien Artist (2), 2021

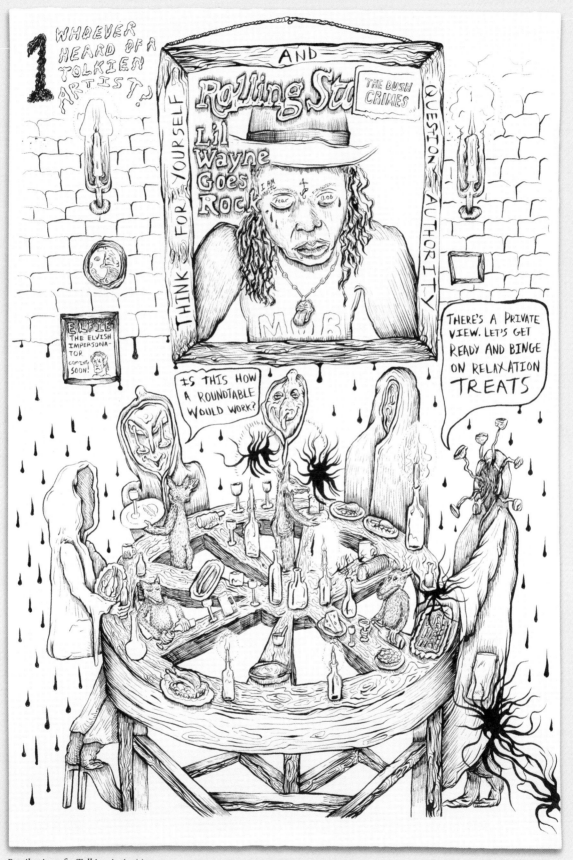

Retribution of a Tolkien Artist (1), 2021

the narrative, the comic coerces undercurrents of hypocrisy and alienation into an allusive dungeon crawl through a temple of recherché treasures. Attendants haunt the gallery's halls as custodial automata, hollow suits of armour that ventriloquise institutional protocols, while the simultaneous exhibition of Edward Armitage's painting *Retribution* (1858) – which allegorises the first war of Indian independence as a bestial adversary that must be slain – as part of the gallery's permanent collection sadly upends the hollow progressivism of its contemporary displays.

V. FRESHERS WEEK AT MENSIS HIGH

Pandhal is a seasoned adept of "Soulsborne" video games (2009–present), a sadistic dark fantasy franchise developed by auteur director Hidetaka Miyazaki and published to great global acclaim by FromSoftware. Characterised by their "tough but fair" ethos of punishing gameplay, the ashen wastes, sinistral architectures and dispassionate cultures rendered by such titles as *Dark Souls*, *Bloodborne* and *Elden Ring* have coldly mirrored a pop nihilism wrought by the calcification of neoliberalism's pitiless expectation of personal improvement. These games furnish Pandhal with both a ludic vocabulary *and* an acidic analogue for marketised arts education, a milieu he knows all too intimately as an ex-student and itinerant lecturer.

Conditions of "hollowness" and "humanity" alternate for Soulsborne players, as avatars run a malicious gauntlet, ascending from lowly states of undead abjection to embodied, messianic godhood, providing the right combination of dexterity and vigilance is employed. For the entered apprentices of a decaying liberal arts education, social manoeuvring, a scarcity of funding opportunities, social media validation, rampant competition, and the psychopathologies induced by being a working-class artist or an artist of colour in a white, upper-middle-class milieu all present their own boss battles in the legacy dungeons of tarnished academies. In the 2020 exhibition "Ensorcelled English: Prestige Repellent" at Goldsmiths CCA, London, Pandhal embraced the macabre genre

trappings of "schoolhouse gothic" to inhabit this allegorical space. The two-part video *Ensorcelled English* portrays an art school hauntingly flooded with white spirits, an agent of erasure perhaps responsible for the pedagogical mainstay of the "all white syllabus". The film also shows hapless students with their heads trapped in elongated hexagonal iron cages, a reference to one of *Bloodborne*'s most iconic set pieces, the "Mensis Cage", sported by the tormented scholars of a legendarily cursed school.

According to the game's densely constructed lore, this unusual headwear embodies an eldritch intellectual ambition, "a device that restrains the will of the self, allowing one to see the profane world for what it is". But it is also, sadly, for any keen-eyed observer, precisely the apparatus that delivered these scholars to their current state of torment. For Pandhal, the Mensis Cage seems to concatenate the conflicting trajectories of social mobility and impoverished pedagogy in its welded iron bars, somehow embodying the awful deadlock of personal doubt and dejection that might be unleashed by deceptive educational apparatuses.

VI. STONE CEILINGS

Dragonpiece, 2022, is the mithril crown of Pandhal's nascent "Pintooverse", the Sikh-

Stills from *Ensorcelled English Rector's Cut*, 2021

inspired fantasy world that his varied works are coming to populate. It's a work that's as visually light and uncluttered as it is rhetorically resolute and lyrically hardened. Recalling the arresting informality and "based" confessional character of American rapper Lil B's music videos, the short film shows the artist rapping on his bed, slaying a video game dragon and communing with his painfully beautiful ragdoll cat Kasha. "Didn't dream of dragons cause we couldn't even go to sleep," he rhymes in the song's opening line over a melancholic synth warble, "spending all night in the taverns drinking ourselves underneath our feet".

The words are a remarkable instance of Pandhal's allusive dexterity, his ability to tie obtuse references into densely shaded articulations of personal feeling. An opaque allusion for many of us, his "dream of dragons" refers to Indian fantasy author Deepa D's essential contribution to the RaceFail debates on diversity in genre fiction throughout the late noughties. "Asking an author to write the Other with respect and assuming it to be sufficient, is like telling a person that being polite to everyone is sufficient in their goal of being an anti-racist ally," she writes, "this is crap. Your definition of individuality, just like your definition of politeness is culture-specific."[4] D's riposte emerged among a tide of white indignation that saw the policing of entirely justified expressions of anger or upset, and the renunciation of discursive emotion as an "excessive", "disruptive" or "rude" inhibitor of supposedly level-headed argument. As NK Jemisin makes plain in her own blogpost on the subject, similar arguments for greater representational nuance had been made in a calm and reasoned manner by writers such as Samuel Delany, Octavia Butler and Joanna Russ for years prior to the debacle. In his own articulations, specifically the 2018 drawing *I Didn't Dream of Dragons*, Pandhal paraphrases D to state the case simply: "If we can have werewolves, we can have Black people."

With *Dragonpiece*, Pandhal twins this brief but complex reference with comments on sleep, self-medication and personally wrought armories of defence and resilience – "Working on the next thing after working on the next

thing, we need so much reassurance so we level up all our weapons" – harking back to the often fraught circumstances of highly pressurised and poorly remunerated cultural production in which practitioners not only need to get on their knees for bursaries and funding but also display appropriately public behaviours of recognition and gratitude for handouts that do little to assuage the unceasing anxiety of economic precarity.

In a 2002 essay discussing the possibility of a "radical fantasy", Fredric Jameson attempted to look beyond the genre's inherent conservatism to identify its usefulness in resituating us in the "concrete social world of alienation and class struggle".[5] He alights on *Earthsea*, 1964–2018, the young adult stories of American author Ursula K Le Guin (an occasional influence on Pandhal), in which he locates the primacy of performative speech acts in the Bildungsroman, suggesting that they function as a meditation on the technology of magic conceived as a kind of "figural mapping" of active and productive subjectivities in their "non-alienated states". In other words, they suggest something of the possibility that different worlds might be spoken into being. Pandhal would probably be the first to skewer any presumption of "radicality" in his own work, let alone the feasibility of any "non-alienated" state, yet Jameson's sentiments seem to resonate with the fabulist nature of his lyrics, with the mythopoetic hopes embedded in their irregular phrasings, with their disarticulation of the operative fictions of race, and ultimately, with the wondrous protean language of the Pintooverse.

Endnotes

1 "White Protagonism and Imperial Pleasures in Game Design #DIGRA21", Medium, 30 November 2021.

2 Harrison, M John, "What it Might be Like to Live in Viriconium", www.fantasticmetropolis.com/i/viriconium, accessed 25 October 2023.

3 Young, Helen, *Race and Popular Fantasy Literature: Habits of Whiteness*, New York and Abingdon: Routledge, 2016, p 10.

4 D. Deepa "I Didn't Dream of Dragons", *Kabhi Kabhi Mere Dil Mein, Yeh Khayal Aata Hai...*(blog), 13 January 2009 www.archive.ph/bwQPl, accessed 25 October 2023.

5 Jameson, Fredric, "Radical Fantasy", *Historical Materialism*, vol 10, no 4, 2002, pp 273–80.

DIDN'T DREAM OF DRAGONS 'CAUSE
WE COULDN'T EVEN GO TO SLEEP

SPENDING ALL NIGHT IN THE TAVERNS
DRINKING OURSELVES UNDERNEATH OUR FEET

WORKING ON BUNIONS ON THE BEAT

PEELING YOUR ONIONS WITH OUR FEET

MAKING FIRST CONTACT WITH YOUR SLEET

MIGHT AS WELL SAY WE'RE WORKING FOR FREE

WORKING ON THE NEXT THING AFTER
WORKING ON THE NEXT THING

WE NEED SO MUCH REASSURANCE
SO WE LEVEL UP ALL OUR WEAPONS

TAKE UP DEFENSIVE POSITIONS
PUTTING UP SHIELDS AND CRAVING DISTANCE

Above
Lyrics from *Dragon Piece*, 2022

Opposite
Stills from *Dragon Piece*, 2022

Still from *Dragon Piece*, 2022

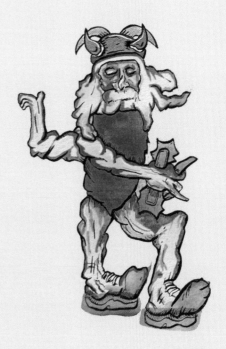

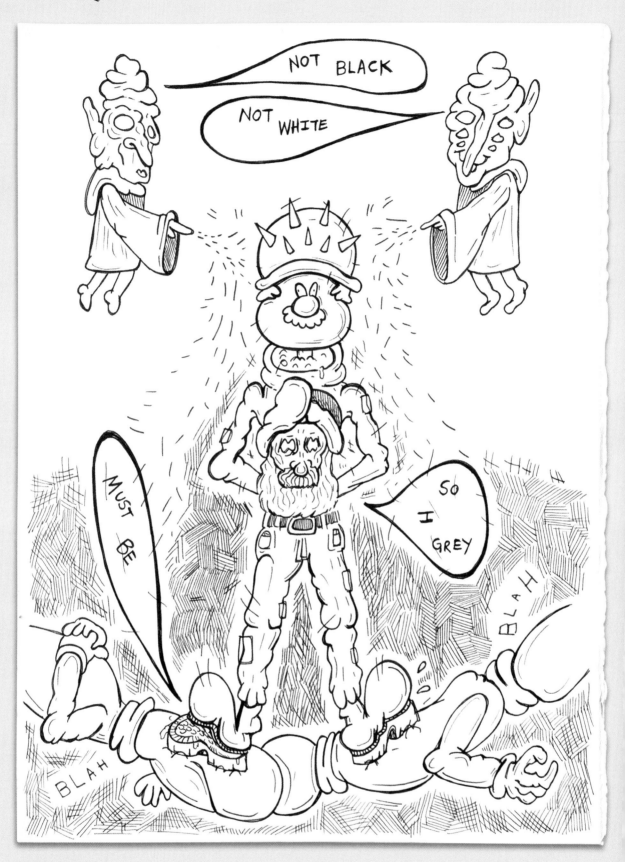

Rebirth of Sepoy Man, 2023

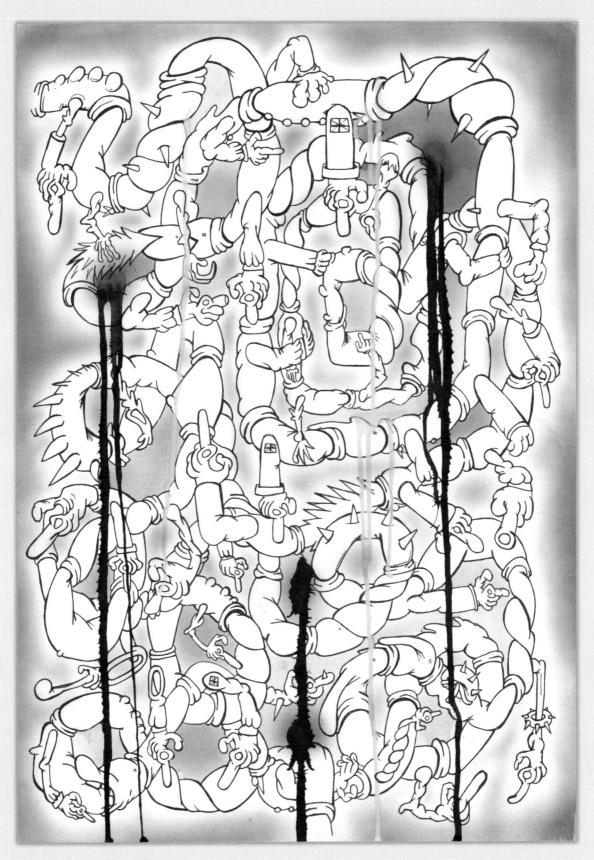

Dagger Strokes For Different Folks, 2024

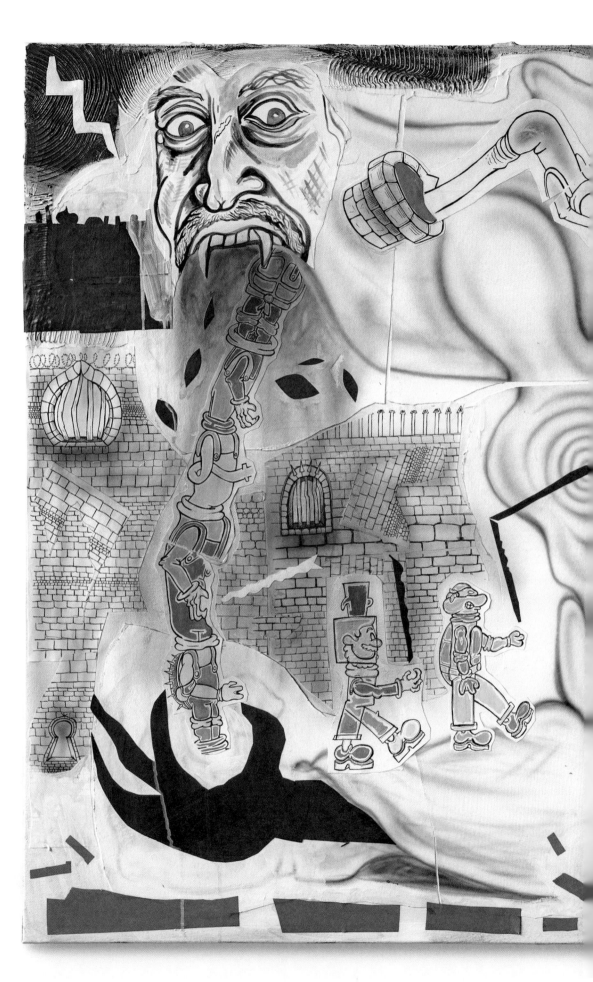

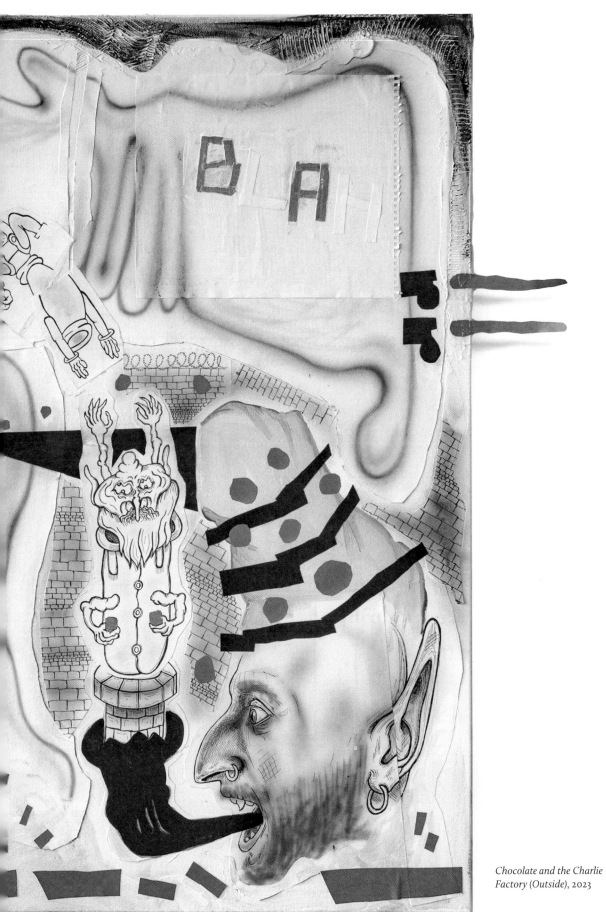

Chocolate and the Charlie Factory (Outside), 2023

ARTIST'S BIOGRAPHY

Hardeep Pandhal has shown work in numerous solo and group exhibitions, including Midland Arts Centre (MAC), Birmingham (2025, forthcoming); New Art Gallery Walsall (2023); British Art Show 9, Manchester, Wolverhampton, Aberdeen (2021 – 22); Goldsmiths Centre of Contemporary Art (2020); Tramway, Glasgow (2020); New Art Exchange, Nottingham (2019); Whitechapel Art Gallery, London (2019); South London Gallery, London (2018); New Museum, New York (2018); Nottingham Contemporary, Nottingham (2018); Eastside Projects, Birmingham (2017) and Modern Art Oxford, Oxford (2016). His work has also featured in exhibitions with Jhaveri Contemporary in Mumbai (2021) and in solo presentations at Frieze London (2018) and Art Basel, Basel (2023).

Pandhal was born in Birmingham, UK in 1985. He received his BA from Leeds Beckett University, Leeds in 2007 and an MFA from Glasgow School of Art, Glasgow in 2013. Pandhal was selected for Bloomberg New Contemporaries in 2013, shortlisted for the Jarman Award in 2018 and received the Paul Hamlyn Award for Artists in 2021. His work is in numerous public collections, including those of the Arts Council, the British Council and the Gallery of Modern Art Glasgow.

CONTRIBUTORS

Zahid R Chaudhary

Zahid R Chaudhary is Associate Professor of English at Princeton University, specialising in postcolonial studies, visual culture, and critical theory. He has published widely on contemporary art, film and cultural politics.

Gabrielle de la Puente

Gabrielle de la Puente is a writer from, and based in, Liverpool. She co-runs *The White Pube*, where she publishes criticism on art, video games and the wider creative industries. She is Director and Curator at OUTPUT gallery, where she platforms artists exclusively from or based in the Liverpool City Region.

Hammad Nasar

Hammad Nasar is a curator, writer and strategic advisor. He is a Senior Research Fellow at the Paul Mellon Centre for Studies in British Art, part of Yale University. Recent curatorial projects have included *Divided Selves: Legacies, Memories, Belonging* (2023), *British Art Show 9* (2021–22) and the Turner Prize 2021 exhibition. He was awarded an MBE for services to the arts in 2023.

David Steans

David Steans is an artist and writer based in Leeds. Recent projects include *Mummy Hood Nesting Forest* (2022), *Puppy the Goblin* (2020), screened at Tate Britain in 2022, and "Curtainz", for *Documents of Contemporary Art: Magic*. He teaches at numerous UK universities including Leeds Arts University, where he is Course Leader of MA Fine Art. He was part of the co-founding year of School of the Damned, and has a practice-led PhD in Fine Art from University of Leeds (2019).

Jamie Sutcliffe

Jamie Sutcliffe is a writer, curator, and co-director of Strange Attractor Press. He is the editor of *Documents of Contemporary Art: Magic* and *Weeb Theory*. He has written for *Art Monthly*, *Frieze*, *Rhizome* and *The Quietus*, among other publications.

LIST OF WORKS

p. 91. *Pintooverse Comic Intro (Page 3)*, 2023. Ink and acrylic on paper. 41.7 x 29.5cm

p. 94. *British Sikh Soldier*, 2012. Ink and graffiti marker on paper and wood. 41.7 x 29.5cm

p. 95. *British Sikh Soldier (Four Lions Requiem 2)*, 2012. Ink on paper. 30.5 x 22.5cm

p. 98. *Respect my BAME (name change)*, 2015. Printed plastic, spray paint, graffiti pen and comic strip. 52 x 80 x 34cm

p. 99. *Mother India*, 2015. Printed plastic, spray paint and graffiti pen. 83 x 65 x 42cm

p. 103. *British Sikh Soldier*, 2012. Ink on paper. 21 x 30cm

pp. 104 and 105. *Thugs and Vandals, Charmed By Gorgoroth XI*, 2021. Indian ink on paper. 56 x 76cm

p. 109. *Spell Concentration 2* (detail), 2023. Acrylic and embroidery patch on canvas. 150 x 120cm

p. 111. *A Silence That Speaks Volumes*, 2023. Acrylic, paper collage and embroidery patch on canvas. 150 x 120cm

pp. 112 and 113. *A Familial Romance* (diptych), 2023. Acrylic, ink and paper collage on canvas. 40 x 50cm each

p. 115. *Untitled (Bridge of Blah Blah Blah Blah)*, 2023. Acrylic and paper collage on canvas. 120 x 80cm

p. 116. *Ensorcelled English*, 2020, HD animation with sound. 13 mins 40 seconds. Installation view at Goldsmiths CCA, London, 2021. Photo: Mark Blower

p. 117. *Ensorcelled English*, 2020, HD animation with sound. 13 mins 40 seconds.

p. 120. *I Didn't Dream of Dragons*, 2018. Ink, gouache and pencil on paper. 56 x 76cm

p. 124. *Retribution of a Tolkien Artist (3)*, 2021. Ink on paper. 56 x 38cm

p. 125. *Retribution of a Tolkien Artist (5)*, 2021. Ink on paper. 56 x 38cm

p. 126. *Retribution of a Tolkien Artist (2)*, 2021. Ink on paper. 56 x 38cm

p. 127. *Retribution of a Tolkien Artist (1)*, 2021. Ink on paper. 56 x 38cm

p. 128. *Ensorcelled English Rector's Cut*, 2021. HD animation with sound, 31 minutes 52 seconds

pp. 131 and 132. *Dragon Piece*, 2022. HD YouTube video, 2 minutes 50 seconds

p. 134. *Rebirth of Sepoy Man*, 2023. Ink on paper. 39 x 26cm

p. 135. *Dagger Strokes For Different Folks*, 2024, Ink and acrylic on paper, 42 cm x 59 cm.

pp. 136 and 137. *Chocolate and the Charlie Factory (Outside)*, 2023. Acrylic, ink, gold leaf and paper collage on canvas. 120 x 155 x 4cm

p. 143. *Make Me Nauseous*, 2017. Printed plastic, graffiti marker, powder-coated steel. 80 x 150 x 50cm

ACKNOWLEDGEMENTS

This book would not be possible without the generous support of Jhaveri Contemporary and Creative Scotland.

Hardeep Pandhal would like to thank the editor, Anita Dawood and the writers – Zahid R.Chaudhary, Gabrielle de la Puente, Hammad Nasar and Jamie Sutcliffe. Thank you to David Steans for participating in a rich In-Conversation.

A further thank you to Adam Sinclair, Stefan Sadler, Joe Howe, Amanprit Sandhu, Billy Teasdale, Vandalorum, Mister Ugly and Kasha for their collaborative support. Last but not least, thanks to Ayla Dmyterko for her loving encouragement.

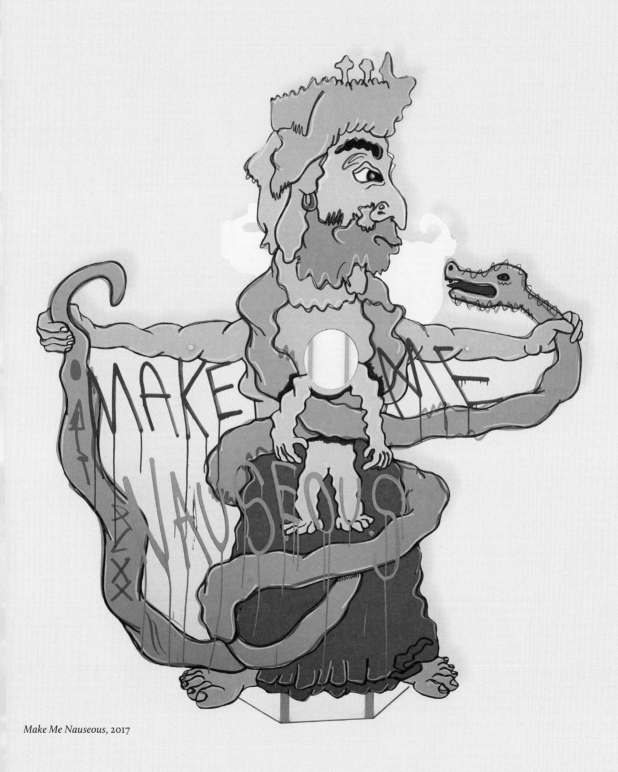

Make Me Nauseous, 2017

© 2024 SJH Group, the artist, authors and photographers

This book is published by Black Dog Press Limited, a company registered in England and Wales with company number 11182259. Black Dog Press is an imprint within the SJH Group. Copyright is owned by the SJH Group Limited. All rights reserved.

Black Dog Press
The Maple Building
39–51 Highgate Road
London NW5 1RT
United Kingdom

+44 (0)20 8371 4047
office@blackdogonline.com
www.blackdogonline.com

Creative direction and design by Anton Jacques
Editor: Anita Dawood
Copy-editor: Susanne Hillen
Printed in Lithuania by Kopa

ISBN 978-1-912165-58-2

British Library Cataloguing in Publication data:
A CIP record for this book is available from the British Library.

This publication was supported by the National Lottery through Creative Scotland.

 black dog press JHAVERI CONTEMPORARY